IMAGES
of America

CHAUTAUQUA
INSTITUTION
1874–1974

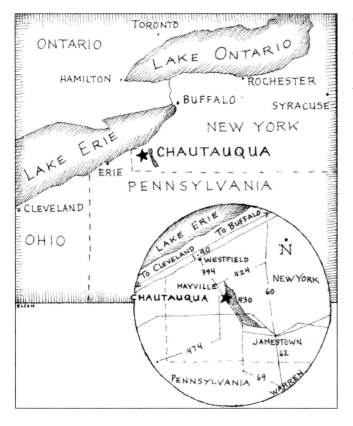

This map shows the relationship of the Chautauqua Institution to area cities. (Courtesy of Jane Nelson.)

Jane Nelson, a local artist and illustrator, is noted for her Chautauqua scenes. (Courtesy of Jane Nelson.)

IMAGES
of America

CHAUTAUQUA INSTITUTION
1874–1974

Kathleen Crocker and Jane Currie

ARCADIA

First printed in 2001.
Reprinted in 2001.

Published by Arcadia Publishing,
an imprint of Tempus Publishing, Inc.
2A Cumberland Street
Charleston, SC 29401

Printed in Great Britain.

Library of Congress Catalog Card Number: Applied for.

For all general information contact Arcadia Publishing at:
Telephone 843-853-2070
Fax 843-853-0044
E-Mail sales@arcadiapublishing.com

For customer service and orders:
Toll-Free 1-888-313-2665

Visit us on the internet at http://www.arcadiapublishing.com

To our fathers, James Barrett Sullivan and Ford Cadwell,
who fostered our love for the Chautauqua region.
To dear Alfreda Locke Irwin (1913–2000), who inspired this endeavor.
We hope to make you proud.

—Kathleen and Jane

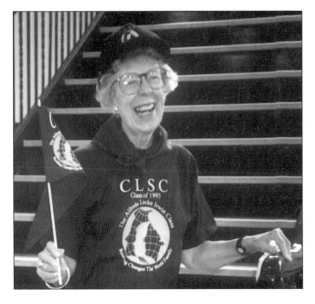

Historian Alfreda L. Irwin was the honoree of the Chautauqua Literary and Scientific Circle Class of 1993.

CONTENTS

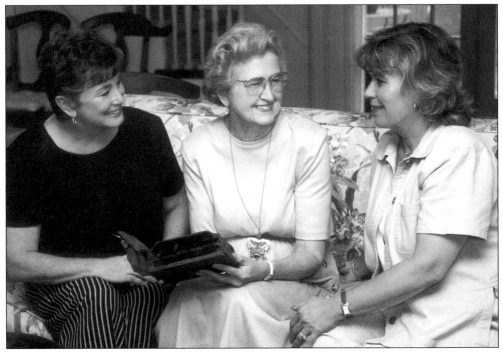

Authors Jane Currie, left, and Kathleen Crocker, right, share a special moment with Nancy Miller Arnn, granddaughter of cofounder Lewis Miller, at the Miller Cottage, August 2000. (Courtesy of Pamela Berndt Arnold.)

Acknowledgments

With deep appreciation to June Miller-Spann, curator of archives and collections manager, the Chautauqua Institution, whose total support and encouragement from the outset made this book a reality; her assistance was truly invaluable. Unless indicated otherwise, the images in this book are courtesy of the Chautauqua Institution Archives, Chautauqua, New York.

To Byron and Ed, who kept us on task with their love, patience, and encouragement.

To Peggy Snyder and Pamela Berndt Arnold for their technical assistance, enthusiasm, and friendship.

To Joan Fox for her editing expertise and generosity.

To Isabel and Norman Pedersen and Casey Redington for their editing and continued support.

To Jane Nelson for her graphics and efforts on our behalf.

To Nancy Miller Arnn, Mary Frances Bestor Cram, and the Samuel M. Hazlett family for sharing their memories and photographs.

To our generous friends who shared their private collections with us. Their names appear beneath their borrowed images. We are extremely grateful to each of you.

INTRODUCTION

With the staggering amount of information and images housed in the Chautauqua Institution Archives, the authors deliberated over their selections and regret any omissions. The intention of the book, however, is to present an overview rather than a comprehensive history of the area. The individual chapter introductions and the bibliography are included to serve as background and reference; every effort has been made to ensure accuracy.

This 1910 postcard message expresses the typical sentiments of Chautauqua visitors then and now. (Courtesy of John Cofield.)

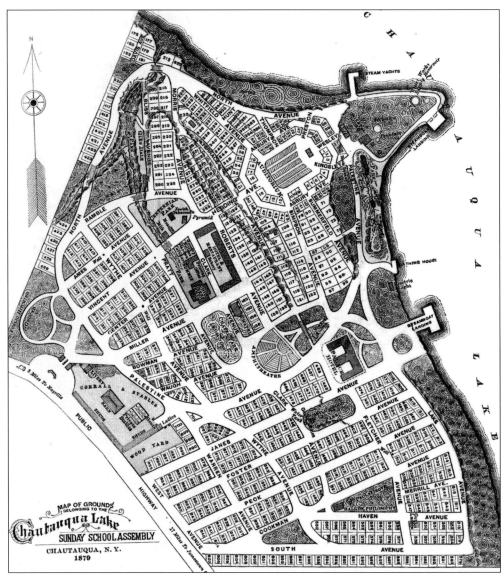

This is an 1879 map of the grounds belonging to the Chautauqua Lake Sunday School Assembly. (Courtesy of Harriet Minnigh.)

One

THE ASSEMBLY
AND ITS COFOUNDERS

Lewis Miller (1829–1899) and John Heyl Vincent (1832–1920), the cofounders of Chautauqua, met through their involvement in the Methodist ministry in the late 19th century. They became lifelong associates but, more importantly, together they masterminded what evolved into a vigorous movement in popular education in America.

Miller had served as superintendent of Sunday schools in Akron, Ohio, while Vincent, born in distant Tuscaloosa, Alabama, became an ardent Methodist preacher at the age of 18. These devout Christians recognized the importance and value of thorough Sunday school instruction and the need for securing competent Sunday school teachers. Although ministers and religious educators of all denominations in those days were expected to be community leaders, all too often their performance and knowledge were inadequate.

Offering the only opportunity for literacy to many of Chautauqua's attendees, Miller and Vincent developed and organized an intensive two-week study course for a broader and more effective religious education training, comparable to the normal school preparation for public school teachers. Both Miller and Vincent lacked formal college education and fervently believed in the sound doctrine that the more education an individual had, the better that person could serve God and society. Society would change for the better only if individuals bettered themselves.

Although self-educated and successful, they identified and sympathized with individuals who hungered for more education. As a result, they were determined to expand Bible study curriculum to include lectures, class drills, and discussion. They considered religious instruction, coupled with other disciplines, expressions of the human spirit.

Having decided upon the curriculum for this proposed summer session, Miller and Vincent then needed to select the perfect spot for teachers and students to meet and exchange ideas. Both feared the demonstrative camp-meeting mentality, especially Vincent, who despised noisy evangelism.

Miller advocated an outdoor setting of natural beauty already familiar to him: property acquired for the Methodist Episcopal church on the shore of Chautauqua Lake in southwestern

New York State. On August 4, 1874, the first Chautauqua Assembly was held at Fair Point, New York. It was renamed Chautauqua in 1879 and the Chautauqua Institution in 1902. Its peaceful setting in a charming grove, its clear air and cool evenings, its proximity to major cities, villages and towns, and its reliable railroad and steamboat connections made it a desirable location.

Anxious to reach their destination during the annual summer pilgrimages to Chautauqua, vacationers often traveled many miles. Transportation, however, was fairly efficient even in the early days of the Chautauqua Assembly. In 1827, the "Great White Fleet" of majestic steamboats began operating on Chautauqua Lake, and the opening of the Sunday School Assembly stimulated even further vessel construction. Fourteen steamers plied the waters daily by 1898, and a total of 60 were eventually in operation. At the end of the 1907 summer season alone, the Jamestown newspaper reported that 280,000 passengers had been carried up and down the lake.

With its advantageous location and its accessibility by various modes of transportation, Chautauqua became a desirable summer retreat in a relatively short period of time. It was totally self-sufficient. It had all the conveniences of a large town year-round, including its own post office, grocery store, hotel, and newspaper office, not to mention its power station, waterworks, and sewage system.

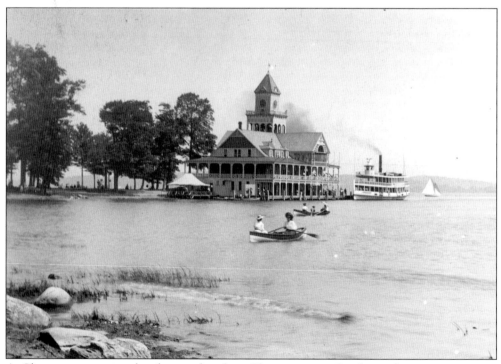

A Chautauqua tourism brochure referred to Chautauqua as "a place where your vacation experience can be as leisurely or active as you see fit." (Courtesy of Jane Currie.)

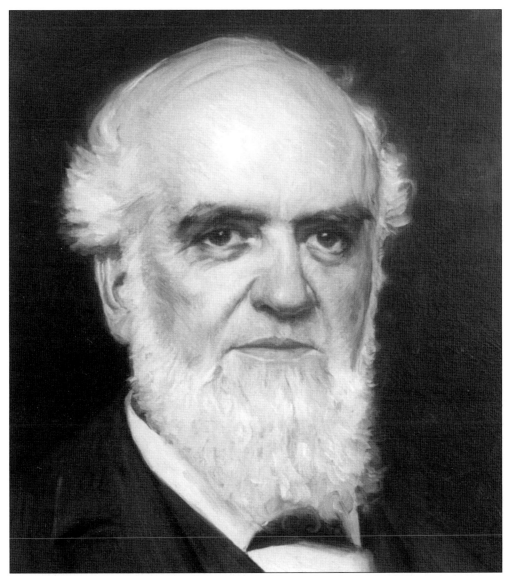

In addition to his Christian leadership in Akron, Ohio, cofounder Lewis Miller was a respected industrialist, educator, and inventor. In 1858, the successful manufacturer patented his Buckeye mower and reaper. He not only taught religious instruction at the Chautauqua Assembly but also ably managed its business affairs while serving as Chautauqua's first president from 1874 to 1899. Harvey Firestone, a business friend, summed up Miller's invaluable contribution to Chautauqua's success when he said that Miller "combined two qualities rare in any man, namely genius and ability in the field of science and a practical vision of the spiritual and education needs of America." Partner John Heyl Vincent, who outlived Miller by 20 years, credited Chautauqua's early success to Miller's "liberality . . . ability, and fidelity." There can be no doubt that Miller's wisdom and leadership cemented the strong foundation for Chautauqua's educational vacation, combining pleasure, physical well-being, and intellectual, spiritual, and social stimulation that has continued uninterrupted at Chautauqua for more than 126 years. This c. 1922 portrait of Lewis Miller hangs in the Miller Cottage. (Courtesy of Nancy Miller Arnn.)

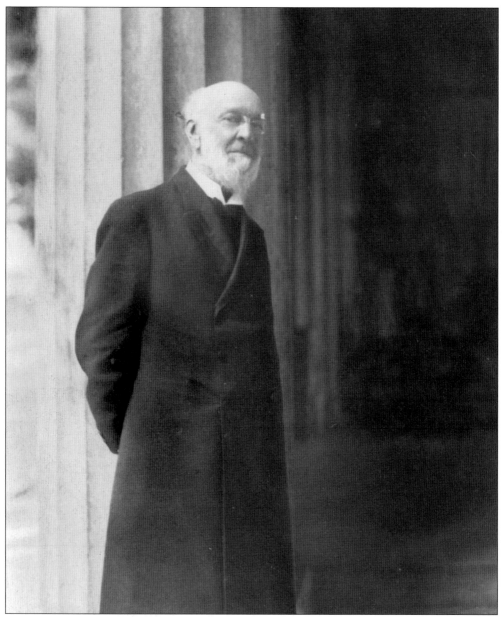

John Heyl Vincent was elevated to the status of bishop of the Methodist Episcopal church in 1888. In 1904, he retired from his position as chancellor of the Chautauqua Institution but retained the title of chancellor emeritus and continued to receive the veneration and love of his Chautauqua family. His magnetic manner and effective oratory transformed the lives of thousands who joined the Chautauqua Literary and Scientific Circle. Endearing accolades on his 80th birthday included these words of praise: "a prince of a man," "a liberator," "a prophet of the people," and "a practical man of vision." It was reported in the September 1916 issue of the *RoundTable* publication that "whether it was a vesper service, a speech at a class meeting, or at a circle council, the Bishop's presence was like a benediction." At his memorial service in 1920, longtime friend Jesse L. Hurlbut summarized Vincent's achievements on earth, proving he had "the voice of a leader, calling men onward, toward the heights."

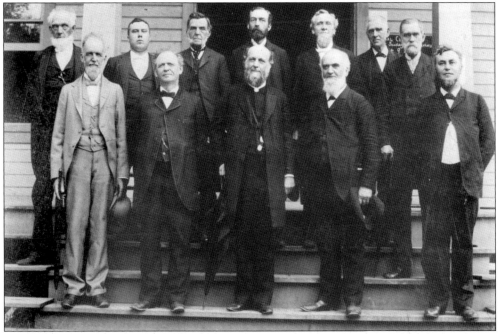

John Heyl Vincent and Lewis Miller, third and fourth from the left, are pictured on the steps of Normal Hall with members of the institution's board. The two visionaries were thought to "stand and abide as brothers with a perfect mutual understanding and a spirit of love."

Elizabeth Dusenbury married John Heyl Vincent in Portville in 1858. Although her well-to-do parents were concerned about her marriage to a rather poor Methodist preacher, the couple had a steadfast marriage. With her passion for literature, her superlative intellect, and her shrewd judgment of human nature, she provided a perfect complement to her husband's idealism.

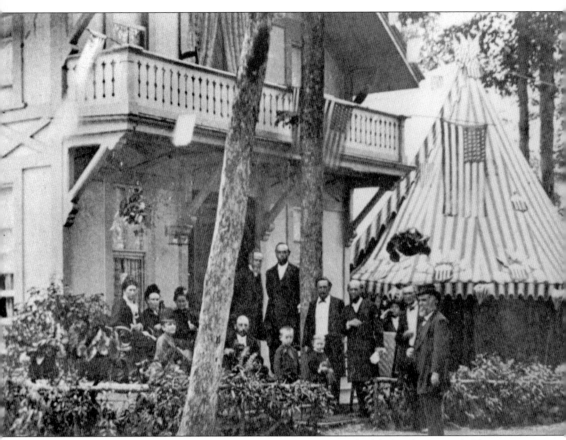

John Heyl Vincent felt the need for a person of stature to highlight the second Chautauqua Assembly in 1875. Since Ulysses S. Grant had been Vincent's parishioner in Galena, Illinois, and his lifelong friend, it was decided after some deliberation that the president was the perfect choice. As a result, the Miller Cottage and a black-and-white-striped tent addition were erected to accommodate President Grant during his visit. It was reported that Lewis Miller entertained Grant "with urbanity, ease, and elegance." Much of Grant's time was spent sitting on his host's wide veranda, with a panoramic view of the nearby auditorium and the lake. (Courtesy of Nancy Miller Arnn.)

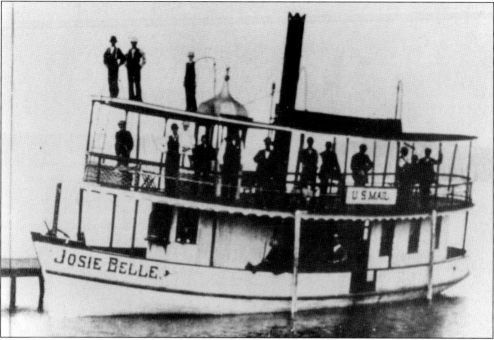

Thousands gathered at the Chautauqua Pier to greet the gaily decorated, 55-foot *Josie Belle*, one of the smallest steamboats in the "Great White Fleet." With Pres. Ulysses S. Grant, the presidential party, an Associated Press agent, and staff correspondents from every major daily newspaper aboard, the steamer left Jamestown for Fair Point and led a grand procession the entire length of the lake. (Courtesy of Vic Norton Jr.)

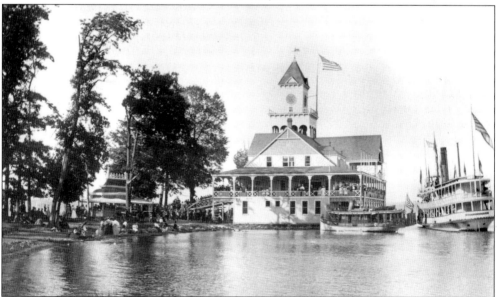

Onlookers and a throng of admirers numbering nearly 2,000 assisted John Heyl Vincent and Lewis Miller in the hearty welcome of the soldier president. Grant's visit succeeded, as planned, in drawing national attention to Chautauqua, helping ensure its prominence. It set a precedent for future U.S. presidents, nine of whom have visited before, during, or after their term of office.

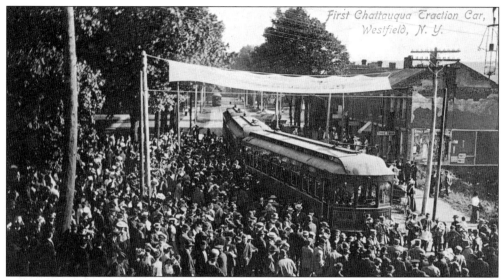

Located in southwestern New York State, Chautauqua is situated 75 miles southwest of Buffalo and within a 500-mile radius of Chicago, Pittsburgh, Cleveland, New York City, Rochester, and Toronto. Passengers arrived daily at Chautauqua County railroad depots in Westfield on Lake Erie and Jamestown at the Chautauqua Lake inlet. In the late 1880s, more than 1,500 laborers laid track that eventually linked the Chautauqua Lake region with Lake Erie and, thus, advanced westward expansion via the Great Lakes. (Courtesy of Kathleen Crocker.)

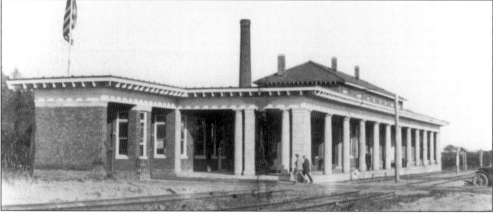

This photograph shows the Chautauqua Traction Station, later referred to as the Main Gate. Entry to Chautauqua was made either here at this depot or at the boat landing.

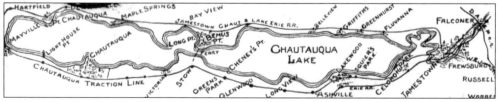

The traction lines were laid on only the east side of the lake. Once travelers reached the various transfer stations around the lake, they could then choose either trolley or steamboat travel for their last leg to the Chautauqua Assembly grounds. Horse-drawn vehicles also transported visitors along the rural roads. (Courtesy of Kathleen Crocker.)

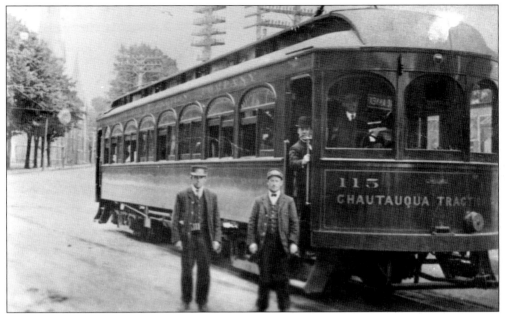

This is a close-up of one of the Chautauqua Traction Company cars, which began to operate in 1904. Many residents have fond remembrances of the large red cars bouncing and rumbling through the backyards of summer homes, meadows, and woodlands en route to the stations. In the winter, when the lake was not navigable, the trolleys linked Chautauqua to nearby communities and kept the institution residents from isolation.

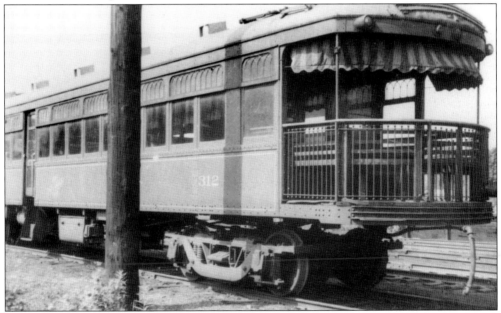

Among the most memorable was Car No. 312. Considered the most luxurious of the electric trolleys, it included special comforts such as velvet seats, a smoking compartment and, best of all, an awning-covered observation platform, which offered not only fresh air but also a scenic view along the lake. After nearly 30 years of travel, it made its last round-trip in 1947 and then, like the other cars, was deliberately destroyed. (Courtesy of Sydney S. Baker.)

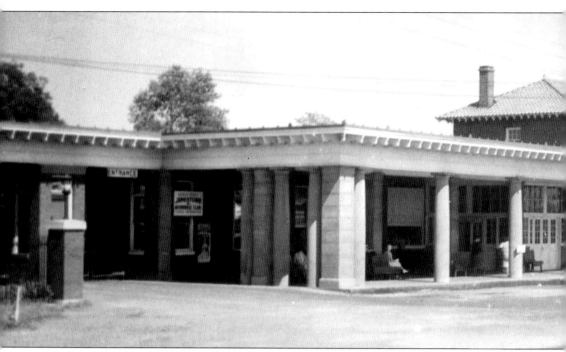

The Main Gate Building, the brick entrance and exit for automobile traffic, was built in 1917 by the Chautauqua Traction Company for $40,000. Since Chautauqua was primarily a pedestrian community, arriving passengers were dropped off at the Main Gate, and drivers parked their vehicles in the parking lot across the road. In the early days, the Main Gate

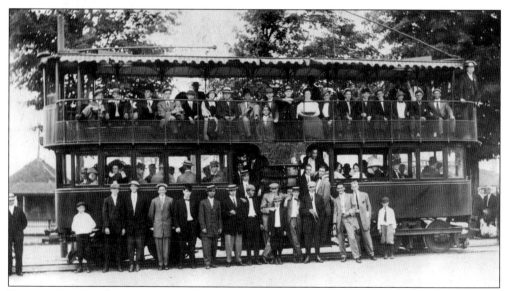

Passengers arriving by steamer were dropped off at the Chautauqua Pier. Those who opted to ride the trolley exited on the platform located on the opposite boundary of the gated community. This double-decker trolley, named *Celoron* for a neighboring village, is typical of the many that were in operation around the lake. On the Sabbath, however, steamers were not allowed to dock, gates were closed to outsiders, and no one was allowed to enter or leave the grounds.

18

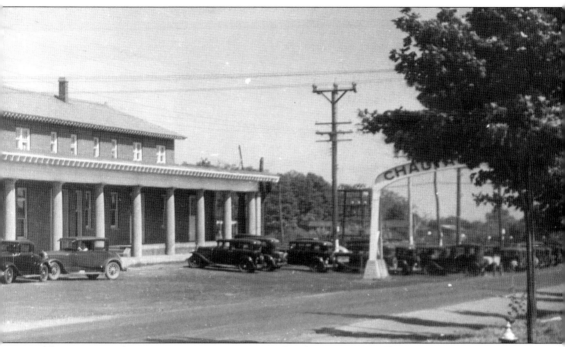

Building contained a passenger waiting room and ticket office as well as an office for baggage freight and express services. The Chautauqua Institution assumed ownership after the traction company no longer needed the building.

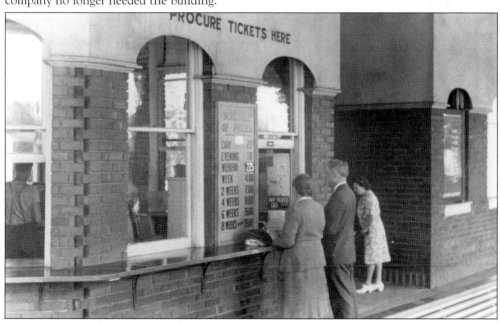

Tickets for general admission and for special evening programs could be purchased at the Main Gate. The gate ticket has been a part of Chautauqua's history since its first year. In 1874, an entry fee was charged at the boat landing gate and at the traction station gate to avoid disturbing people during lectures and services. Daily, weekly, monthly, or season tickets are still necessary for entrance to the grounds.

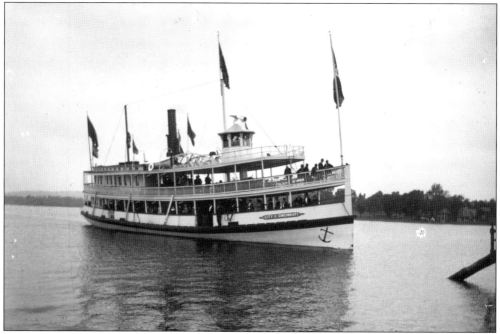

Remaining dockside each night at its home port of Mayville, the *City of Cincinnati*, with its broad deck, deluxe cabins, grace, and speed, was a favorite of passengers. Prior to its destruction in 1938 by a fire of unknown origin, it was purchased, converted, and used as a private residence for several years. (Courtesy of Jane Currie.)

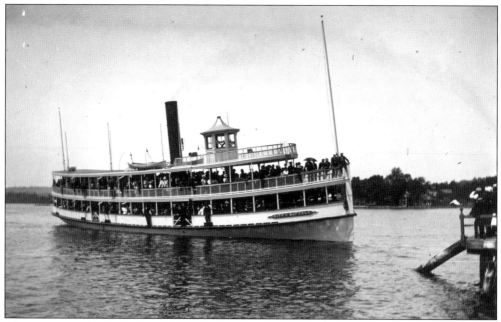

The *City of Buffalo* was built in 1890 in Jamestown and operated for nearly 40 years. It sat high above the water, and when its upper cabin was moved forward to create a dance floor on the second deck, it became a popular floating social center. It was deliberately burned at the Celoron shore on Labor Day of 1929. (Courtesy of Jane Currie.)

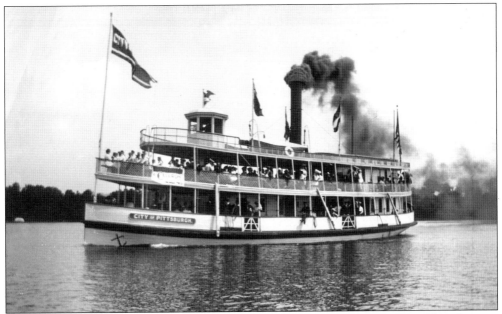

Built in 1875, the *City of Pittsburgh* held the longevity record for active service, although it was demolished in 1919. Like most steamers in the fleet, it was renamed several times. Originally called the *W.B. Shattuc*, it was renamed *Minnehaha* before being christened for the Pennsylvania city south of Chautauqua. The 100-foot, double-decked craft was easily handled by its crew but was lacking in passenger amenities. (Courtesy of Jane Currie.)

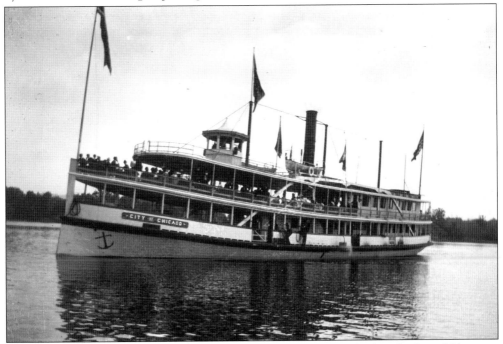

Although most of the steamers were recognized by their distinctive whistles, the *City of Chicago* at 154 feet long was just as easily identified by its size. The largest on the lake, the steamboat was often used for picnic excursions before it was deliberately burned in 1903. (Courtesy of Jane Currie)

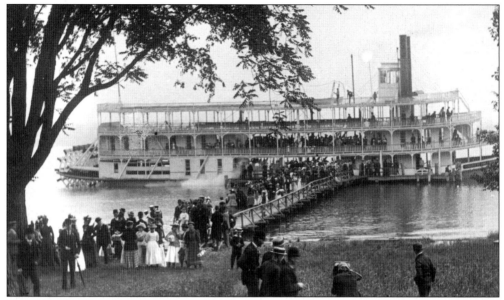

Typically, the *City of Jamestown* stern-wheeler, above, would arrive to unload its 200 passengers and their belongings. Then, 15 minutes later, the *City of Mayville* would tie up, and the baggage masters would meet its 150 passengers as they, too, disembarked. Confusion reigned for those anxious to reach their lodgings; sorting through piles of luggage on the wharf proved frustrating at best. Naturally, the amount of baggage was heaviest at the initial homecoming and, again, at the season's closing. (Courtesy of Jane Currie.)

This particular 1894 steamboat ticket was issued to George E. Merchant "until close of the season unless otherwise ordered." Note the signature of A.W. Broadhead, president of the Chautauqua Steamboat Company. The influential Broadhead family, who founded Jamestown's leading textile and worsted manufacturing company, also owned and operated the Chautauqua Traction Line. (Courtesy of Sydney S. Baker.)

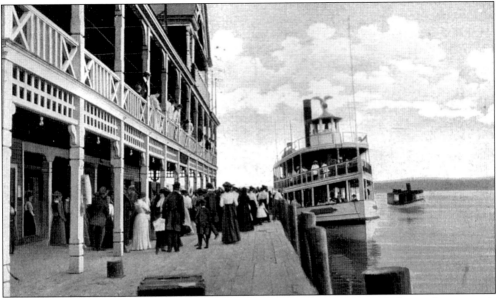

Arriving from Cleveland, Chicago, Pittsburgh, and Buffalo, passengers laden with a season's worth of clothing and household paraphernalia were greeted and assisted by steamboat line employees. (Courtesy of Jane Currie.)

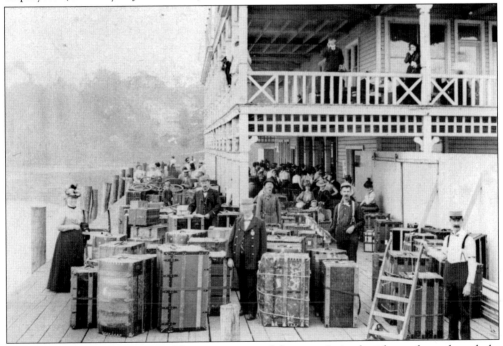

Imagine these items as reported by a passenger of that era: "mixed with trunks and satchels, were mere baskets of provisions, boxes of groceries, bundles of mops and brooms, kegs of nails, bundles of glazed sash, bedsteads, bed slats, feather beds, quilts, tents for the Department of Entertainment, wheelbarrows for the Department of Recreation, books for the bookstore, a mummy for the museum, kegs of paint, cans of oil, cook stoves, boilers, furniture, and empty barrels for the sanitary department."

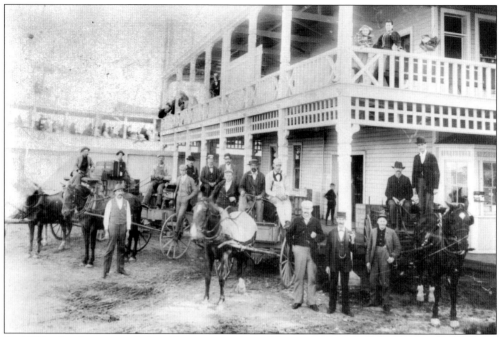

In 1874, the first year of the Chautauqua Assembly, many travelers complained about the problems of arrival. It was reported that "it takes a dozen teams to haul the trunks, etc., up into the woods from the docks. The wharf is so short that only two or three boats may load at the same place, and the warehouse is not large enough to store large amounts of freight."

The boat landing was "literally jammed with the curious and the eager, expectant ones waiting for coming friends. It was with difficulty," the bystander wrote, "that we were allowed our way through to the ticket office to purchase the necessary card for entering." This solitary traveler, sitting atop her trunk, however, seemed able to avoid the congestion in order to pose for this photograph.

Competition among the rival steamboat companies became keen, and captains vied for the most advantageous dock position as they met each train at the Mayville dock and the Jamestown boat landing, hoping to board the greatest number of passengers. As a result, the steamers were often filled beyond their licensed capacity, until overcrowding became a recognizable danger. According to information gleaned from the Fenton Historical Society in Jamestown, "steamboat races, docking arguments, and deliberate rammings" were frequent occurrences. Thus, in 1876, the Chautauqua Lake Navigation Commission was created, and much was done to ensure the safety of steamboat patrons. In 1892, the Chautauqua Steamboat Company was formed to consolidate ownership of the many vessels. This 1935 certificate of inspection verifies that there was a sufficient number of suitable accommodations and life preservers for the specified 60 passengers. (Courtesy of Sydney S. Baker.)

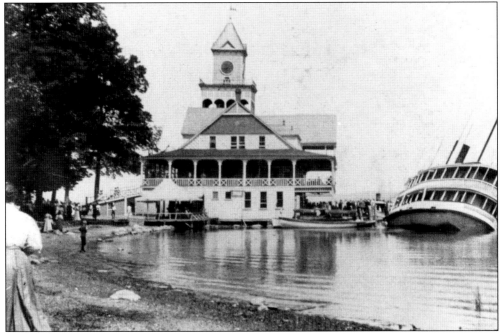

Many Chautauqua County residents have read or remember the story of the *City of Cincinnati*. While the steamer was landing at the Chautauqua dock in 1890, its hull was pierced by a submerged piling. A gangplank extended between the dock and the steamer allowed stranded passengers an escape route. The boat was repaired, and it continued in operation until 1927.

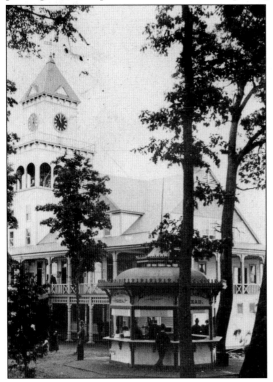

To accommodate the increasing numbers of visitors by steamers, the Pier Building was built at the Fair Point boat landing. The bustling terminal housed a waiting room and the necessary ticket and baggage offices on the ground floor; a promenade, veranda, and shops, which sold miscellaneous items such as Indian souvenirs and etched ruby glassware, on the second floor; and a classroom and dormitory on the third floor. A bell tower topped the building. A nearby candy shack was a popular venue; it sold molasses popcorn balls and provided delivery service on the grounds.

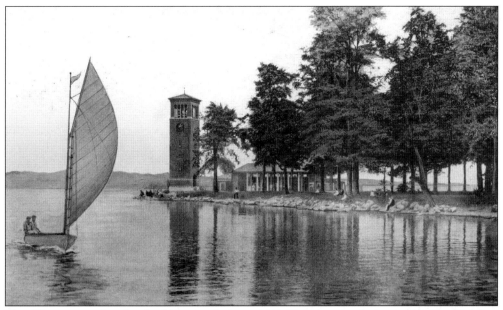

The Chautauqua shoreline's old beauty has survived. Construction between the Pier Building and the lake was restricted to preserve Fair Point's scenery, since the area around the Miller Bell Tower, Miller Park, and Palestine Park were the first to be seen by steamboat passengers. The grounds were and are a popular destination, having the advantage of an invigorating climate, incomparable scenery, and glorious recreational opportunities. (Courtesy of Alan E. Nelson.)

By the late 1870s, the primitive tents erected between the point and the auditorium in the 50-acre tract had been developed into a more civilized village of cottages for the comfort of summer residents. The Miller Park area has retained the sylvan setting of the original encampment and makes a wonderful setting for family activities.

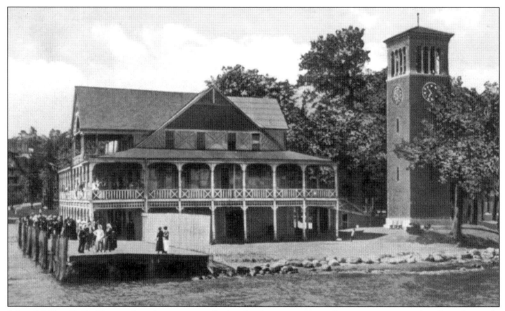

The Miller Bell Tower has been a symbol of Chautauqua and an impressive landmark since 1911, when it was built with contributions from many Chautauquans to memorialize Chautauqua's cofounder Lewis Miller. This classical Italian campanile, with its 75-foot tower, open belfry, rough brick exterior, tile roof, and lighted clocks mounted on all four sides, is visible for several miles up and down the lake. (Courtesy of Kathleen Crocker.)

Buffalo architect Edward B. Green was considered "Chautauqua's architect" because of his contributions to major construction projects at the institution between 1905 and 1917. Among his designs were the Pier Building and the Miller Bell Tower, shown at the top of this page. (Courtesy of the Burchfield-Penney Art Center, Buffalo State University, Buffalo, New York.)

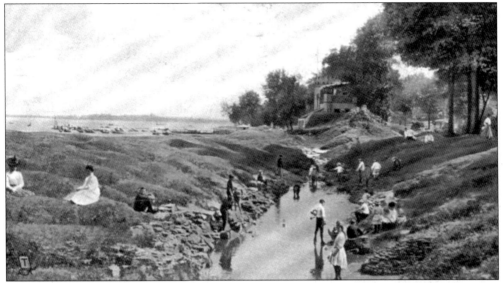

Palestine Park was designed as a special feature of the 1874 Chautauqua Assembly; in 1875, it was rebuilt as a permanent model. Arriving at Fair Point by steamer, people often went directly to the replica located adjacent to the Miller Bell Tower and in the Miller Park area. It is a contour scale model of the Holy Land that cofounder John Heyl Vincent staked out as a meaningful visual aid for Sunday school teachers and their students. Its main purpose has always been as an educational tool. Guided pilgrimages there serve to teach the geography and history of the Holy Land itself and the Bible in general. (Courtesy of Jane Currie.)

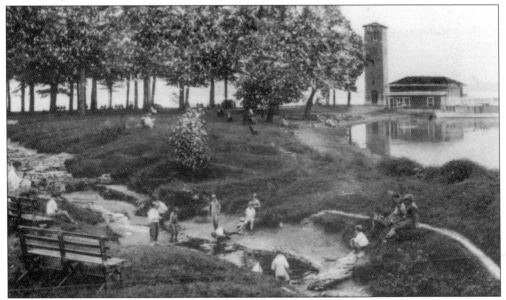

The compass points of Palestine Park are reversed, but Chautauqua Lake at its edge is meant to represent the Mediterranean Sea, the trickle of water is the River Jordan, and the Dead Sea, towns, and cities are depicted with reasonable accuracy. Its exaggerated mountain peaks and ranges are made of perishable materials. Thus, the area has been inadvertently trampled by children and even deliberately used as a place for playing tag, as Ida Tarbell, the famous Chautauqua newswoman, once confessed to doing.

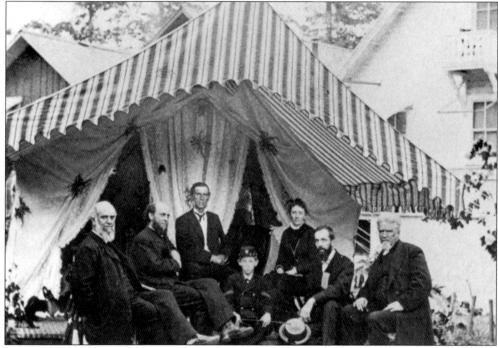

Located beside the Miller Cottage, the Massey family tent was one of the finest on the grounds. Seated at the far left is Lewis Miller, with John Heyl Vincent to the right. Hart Massey, a wealthy Canadian, his son Fred, his sister Lillian, his brother Chester, and an unidentified person are seated next. Hart, Chester, and Vincent Massey served a total of 52 years as members of the Chautauqua Board of Trustees. Chester Massey's connection to Chautauqua was further strengthened by his marriage to Anna Vincent, the cofounder's half-sister.

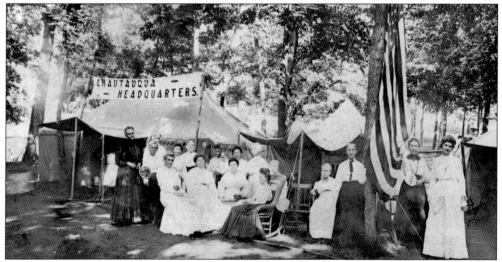

Fair Point was transformed into a permanent village. Tents, either brought to the grounds or rented, were used for sleeping quarters and for meeting places, as indicated in the sign above, "Chautauqua Headquarters." The camp's activities were concentrated in the Miller Park area, the hallowed site of the original auditorium, the speaker's stand, and its lecturers. (Courtesy of John Cofield.)

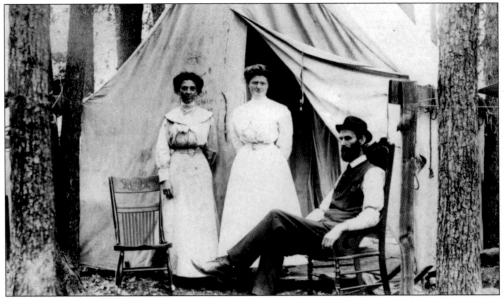

This early family of "tenters" most likely brought their own linens and supplies with them to Chautauqua. They probably took their meals in the communal dining hall with their summer neighbors. With the physical growth of the Chautauqua Assembly and the lengthier sessions, the decline of tent life resulted in the construction of crude cottages on top of the tent platforms. Vacant lots were rare, and cottages of rough hemlock boards were built for as little as $30. By 1878, some of their more elaborate replacements—cottages with mansard roofs, porticoes, balconies, towers, verandas, and bay windows—were valued as high as $1,000.

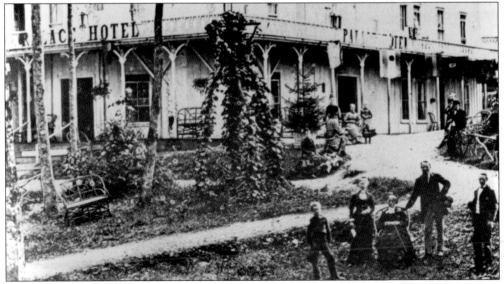

The Palace Hotel was anything but palatial by modern standards; it was neither luxurious nor private. Because visitors mistook the primitive wood-and-canvas structure with its cloth partitions for a barn, a massive hotel sign was prominently displayed. The building itself was originally used at the Philadelphia Centennial in 1876 and was moved to Chautauqua the next year. Chautauqua's first post office was located at the rear of the Palace Hotel, with only a service window for its patrons.

The auditorium, built in 1876 as a rudimentary open-air outdoor amphitheater, immediately became the center of the Chautauqua Assembly's activities. It was located in the heart of the forest grove a short walk from the pier. Its visitors sat facing the lake, seemingly mindless of the uncomfortable, backless hard wooden benches; enthusiasm and the spirit of adventure and pioneering apparently overcame physical discomforts. Nearly 25 tents encircled the auditorium, with the Jamestown contingent outranking the other represented villages. (Courtesy of Louise O'Dell.)

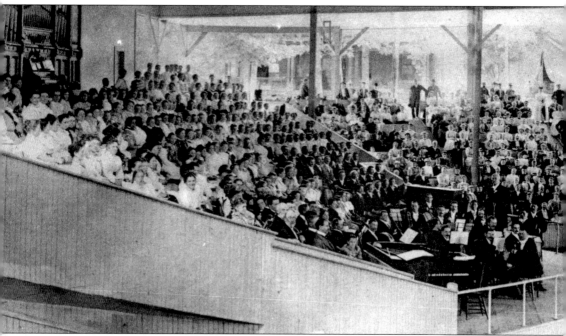

This personal message was written on the back of the above postcard, which was sent to the writer's "Dear Sister" in Missouri and was postmarked June 20, 1909: "Here is a picture of the amphitheater where all the services, concerts, lectures & so forth are held. It seats several thousand . . . This is a beautiful place. We are little over 100 feet from the water's edge. There are some beautiful cottages here but I think the location of this one the prettiest. The water is

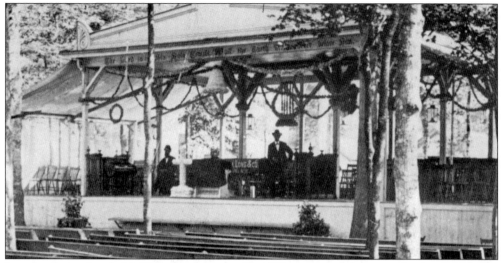

Imagine sitting beside Ida Tarbell on August 10, 1878, on one of those wooden benches facing the speaker's stand in Miller Park as she listened to John Heyl Vincent initiate his proposal of the Chautauqua Literary and Scientific Circle to an eager and entranced audience. She wrote of "this finest of inspirational talks" that "it stirred me so deeply that I have never forgotten the face of the orator [Vincent] nor, more important, the upturned faces of the women . . ." Then, imagine sitting in the modern Chautauqua Amphitheater with its superb acoustics, listening to other stimulating lecturers and performers on its celebrated stage.

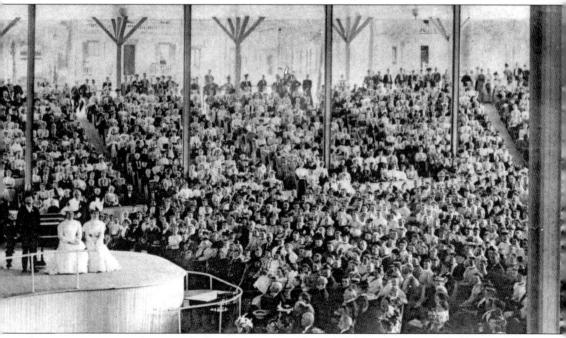

clear we can see way down to the bottom in many places. We are going to take a ride on the lake this afternoon. Alice's cottage is so cozy and clean and comfortable with the nicest porch. We can sit and see the boats and steamers pass. Plenty of rocking chairs couches and cozy corners . . . I sleep so sound the air is so good." (Courtesy of Kathleen Crocker.)

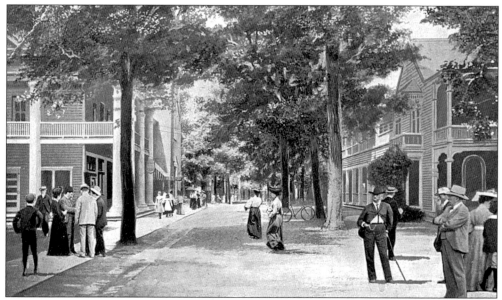

Clark Street, located near Smith Memorial Library, is better known as the Brick Walk. The busy Chautauqua Amphitheater, serving as a community center, is farther down on the left. Attired in vintage dress, these strollers present a tranquil image in the quaint setting. (Courtesy of John Cofield.)

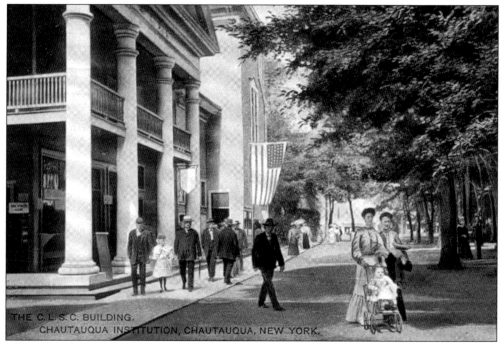

THE C. L. S. C. BUILDING.
CHAUTAUQUA INSTITUTION, CHAUTAUQUA, NEW YORK.

This is another view of the same area, with the Chautauqua Literary and Scientific Circle Building in the left foreground. Notice the formal daytime wear; an atmosphere of busy leisure prevails. (Courtesy of Kathleen Crocker.)

Two

EXPANSION

Chautauqua's initial growth spurt was a direct result of the Chautauqua Literary and Scientific Circle (CLSC) reading course and its ever-widening circles, the Chautauqua Press and, also, the tent chautauquas that suddenly dotted rural areas in the Midwest. In July 1888, a column in the *Chautauquan* acknowledged that "Chautauqua is no longer bounded by the shores of the lake where the movement had its birth. Nearly 50 assemblies have been organized in different parts of the country, and local circles exist in nearly every town and city in the land . . . its students are everywhere." In addition, the numbers of visitors to the Chautauqua grounds had increased significantly.

The CLSC, known as "the oldest continuous book club in America," profoundly affected Americans and their education and became an important avenue of learning. In 1878, cofounder John Heyl Vincent announced his plan for the formation of a four-year guided reading program; this literary study group was designed for citizens everywhere, experiencing leisure for the very first time.

Former Chautauqua historian emerita Alfreda L. Irwin recognized that the CLSC helped satisfy a hunger for knowledge after the Civil War. Timesaving machines introduced during the Industrial Age allowed women in particular to assume new roles. They could receive sufficient education from this unique CLSC home-study course to assist them in their own children's schooling. Women became connected locally, nationally, and internationally with other pledged readers. In time, they ventured outside their homes and bonded with their sisters in reading circles, literary societies, church and missionary undertakings, and social work, for the service of others. The Chautauqua Movement enabled them to gain the education and skills they craved and, thus, permitted them entrance into the social and intellectual mainstream of American life.

Vincent rejoiced at the immediate appeal of this plan to transform the whole of life into a college course via the CLSC. The Chautauqua culture, which fostered the habits of reading and study in connection with the routine of daily life, was quickly spread by missionaries, clerics,

teachers, and readers who had attended the earliest of the assemblies at Fair Point.

Since the CLSC home-reading course did not require a pilgrimage to the Chautauqua grounds, independent local circles developed in communities throughout the nation and abroad. Solitary readers enrolled, encompassing a wide spectrum of ages and occupations. Readers in close proximity bonded and met in private homes and church parlors, at ranches and military posts, and even in prisons for discussion and mutual support in their endeavor to complete the requirements of the stringent but longed-for course.

A testimony to the intensity of circle participation is found in the records of the Brocton Circle, located in the heart of the Chautauqua County grape belt. In 1887, that circle "had an average attendance of 20 even in the very busiest season when every man and woman was picking and packing grapes."

The CLSC and the Chautauqua Movement were "a response to an unspoken demand, a sensitive alertness to the cravings of millions of people for something better." With its emphasis on religious belief, the CLSC became a motivating force for social change and educational advancement and, by 1914, nearly 50,000 had graduated from the four-year course.

Since these were primarily uneducated or undereducated readers struggling to better themselves, most with no references to consult or libraries to visit, they sought guidance and assistance from Vincent and his associates. Established in 1876 by founding editor Theodore L. Flood, the *Chautauquan* became the monthly organ of the CLSC, seeking to address the needs of circle enrollees. Its circulation of 15,000 copies in the first year alone rivaled many popular magazines of that time. The publication helped spread the word of Chautauqua, serving as a further purveyor of expansion.

Other vehicles for the dissemination of the Chautauqua idea were the "little chautauquas" or "tent chautauquas" that appeared in the early 1900s. These independent facsimiles offered culture and entertainment to rural communities and flourished for nearly two decades. The traveling chautauquas suffered hardship during the Depression, and many folded due to lack of support from local businesspeople.

Around the late 1920s, with the advent of improved transportation, radio, and moving pictures, the traveling chautauquas became defunct. Not surprisingly, however, there has been a resurgence of the chautauquas in recent years because the name Chautauqua has always been synonymous with respectability, honest inquiry, self-betterment, open discussion, and healthy recreation—all expressions of the ideal American life.

In 1878, John Heyl Vincent proposed his plan for the formation of the Chautauqua Literary and Scientific Circle to promote habits of reading and study within the routine of daily life. This is a cover of one of the CLSC textbooks. Everyone was welcome to join: "the young, the old, Jew or Gentile, bond or free, black or white, all shades of opinion, members of all denominations, people of all occupations and trades." The CLSC has membership and active circles throughout the nation and the world. (Courtesy of Kathleen Crocker.)

John Heyl Vincent believed that education was a "natural and inalienable right of human souls" and that Chautauqua must exalt education for everyone. In his 1881 book *The Chautauqua Movement*, Vincent detailed his plan. Three of his proposals capture the essence of his beliefs: One, "the whole of life is a school"; two, "the true basis of education is religion"; and three, "in mature life, beyond the limits of the usual school period, the intellect is at its best for purposes of reading, reflecting, and production."

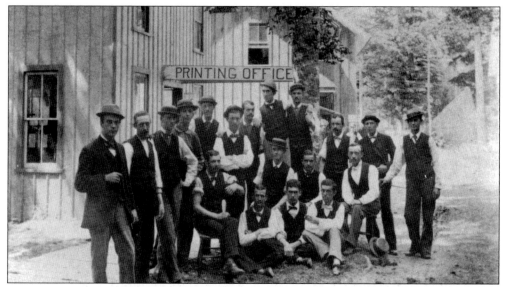

Theodore L. Flood was the founding editor of the *Chautauqua Daily Assembly Herald* and the *Chautauquan Daily*. In his home town of Meadville, Pennsylvania, Flood was both a respected Methodist minister and a newspaperman. After joining John Heyl Vincent at the second Chautauqua Assembly, Flood and his staff moved their printing operation to Chautauqua every summer, and the printing office was a bustling business in the late 1880s.

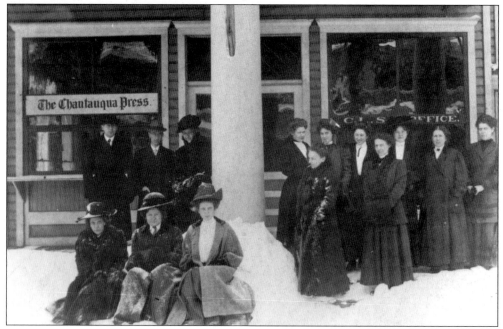

The Chautauqua Press eventually published periodicals and Chautauqua Literary and Scientific Circle books in addition to its newspapers. The advantage of having its own daily publications for every year of its existence, except 1874 and 1875, has been tremendous. Every single detail of the life and events of the Chautauqua community has been chronicled; the comprehensive collection is housed in the Chautauqua Institution Archives for reference. The Chautauqua publications have been called "a magic carpet to bring back the summers on the lake."

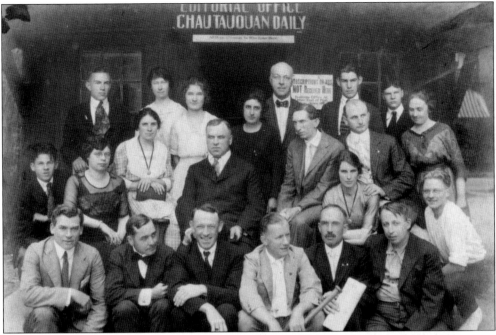

Beginning in 1879, the *Chautauqua Daily Assembly Herald* reported summer lectures, sermons, local news, personals, and insightful editorials, expanding to publish monthly throughout the year. In 1906, the summer newspaper was named the *Chautauquan Daily* and was supplemented yearlong by the *Chautauquan Magazine*. The latter contained book reviews, supplemental Chautauqua Literary and Scientific Circle readings, enrichment articles, and self-study aids. It was affordable and arrived in "timely fashion."

Chautauquan Daily editor emerita Alfreda L. Irwin was the "quintessential Chautauquan." A graduate of Ohio Wesleyan University, her journalism skills led to her role as editor from 1966 to 1981 and then as the official Chautauqua Institution historian for nearly the next 20 years. She was admired for her willingness to share her encyclopedic knowledge of Chautauqua and was the honoree of the Chautauqua Literary and Scientific Circle Class of 1993. She was honored by the National Women's Wall of Fame in Seneca Falls.

Ida M. Tarbell, the self-proclaimed "foremost muckraker of her time," began her career in journalism as a member of the staff of the *Chautauquan*, the monthly magazine of the Chautauqua Literary and Scientific Circle. Theodore L. Flood hired the Allegheny College graduate from Meadville, Pennsylvania, to assist CLSC readers. A member of the CLSC Class of 1887, Tarbell believed that the CLSC stood "for the right of the individual to as much education as she could master."

Ida M. Tarbell worked in conjunction with Kate Kimball, the Chautauqua Literary and Scientific Circle executive secretary. Together they aided those many uneducated readers struggling to master the home-reading course who wrote to the *Chautauquan* for guidance. As this letter to Kimball indicates, Tarbell was a staunch supporter of the Chautauqua Literary and Scientific Circle. Note the CLSC stationery and Tarbell's comment, "So the ripples spread." The membership of the CLSC was growing at a fast rate in 1885.

Nicknamed the "Mother Superior" of the Chautauqua Literary and Scientific Circle by *Chautauquan* editor Frank Chapin Bray, Kate Kimball was essential to the operation of the CLSC and was responsible for advancing it nationwide via its circles. She was hired in 1878 at age 18 by John Heyl Vincent. As her primary responsibility, she handled personal correspondence with circles and more than 25,000 individual readers. To encourage CLSC candidates in pursuit of their goals, she devotedly read of members' discouragements, failures, progress, pleasures, and victories until her death in 1917.

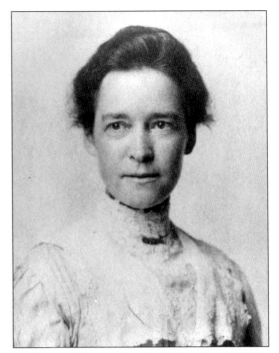

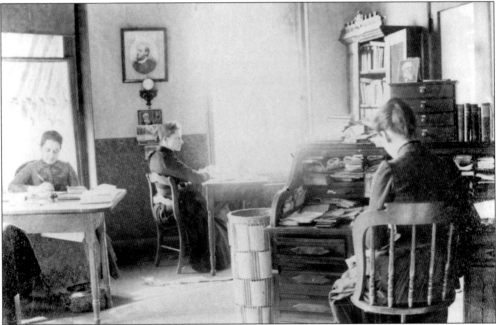

Kate Kimball, a member of the Chautauqua Literary and Scientific Circle Class of 1882, was a powerful role model for readers and coworkers. Seated at the desk on the right, she supervised her female office staff in Plainfield, New Jersey. When John Heyl Vincent moved to Buffalo, Kimball also relocated there, where she was closer to Chautauqua and where her staff probably had more room to handle the deluge of CLSC mail. Duties included detailed record keeping of all graduates and enrollees, the preparation of pamphlets, the securing of advertising, and the ordering of supplies such as diplomas and badges.

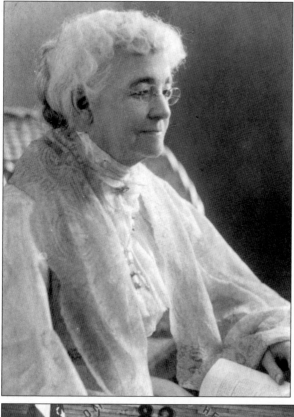

Pictured with one of the Chautauqua Literary and Scientific Circle selections on her lap, Mrs. Bethuel T. Vincent, sister-in-law of cofounder John Heyl Vincent, was president of the Pioneer Class, the first graduating class of the society. She was one of nearly 1,800 who received their hard-earned diplomas, the majority of whom in 1882 were white Methodist women residents of New York, Pennsylvania, and Ohio. Ida Tarbell wrote that women of that time found the CLSC "intuitively . . . practical."

Pioneer Hall was built by the Chautauqua Literary and Scientific Circle Class of 1882. Located near the Hall of Philosophy and Alumni Hall, the single-room building is a museum for memorabilia and artifacts from the earliest classes. Docents describe the class diploma, John Heyl Vincent's desk, executive secretary Kate Kimball's portrait, historic photographs, and an array of period furnishings.

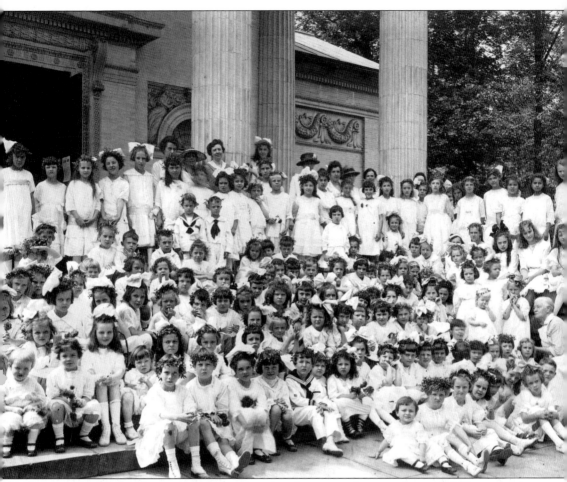

Flower girls—and, in later years, boys—have played an integral part in the annual Chautauqua Literary and Scientific Circle Recognition Day ceremony. Attired in traditional white dresses and crowned with leaved garlands, the girls carried baskets of flowers, which they strew along the pathway of prospective graduates approaching the Hall of Philosophy from the Golden Gate. In the early years, the children were discouraged from returning the smiles of adults due to the solemnity of the service. This photograph captures a group of flower girls in 1918. Seated on the bottom row of steps, second from the left, is Mary Frances Bestor, daughter of Arthur E. Bestor, president of Chautauqua. As an adult, Mary Frances Bestor Cram became a member of the CLSC Class of 1978 and the honoree of the Class of 1996. (Courtesy of Mary Frances Bestor Cram.)

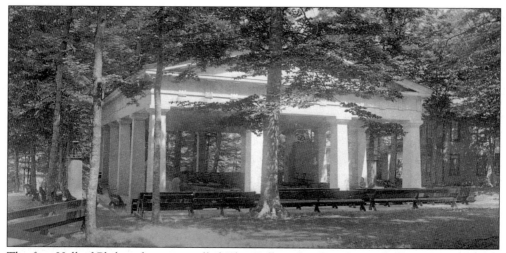

The first Hall of Philosophy, once called "the Hall in the Grove," was built in 1879, a white wooden structure modeled after the Athenian Parthenon. In 1906, it was reconstructed and used not just for Chautauqua Literary and Scientific Circle programs but also for other lectures and presentations. John Heyl Vincent mused: "this hall . . . has a peculiar charm for me. I love the rays of the setting sun, the evening breeze, this mosaic work of light and shadow, these glimpses of the blue sky beyond and the reminders of the long ago when such temples as this stood, much better built and of more enduring material indeed, but with much lower aims and purposes." (Courtesy of Alan E. Nelson.)

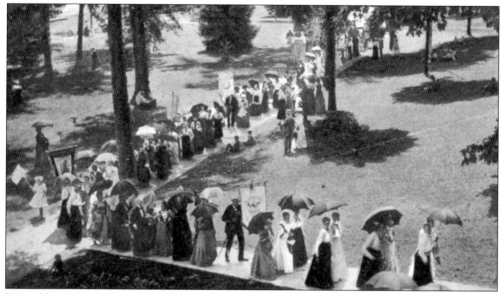

Resembling the traditional college commencement, the elaborate Chautauqua Literary and Scientific Circle Recognition Day ceremony has been held every August since 1882. Parade music, decorated buildings, cheering spectators on balconies, and colorful CLSC class banners all contribute to the pageantry, as the graduating class assembles in the former St. Paul's Grove. Joined by alumni marching and chanting behind their respective class banners, the graduates parade behind their newly unveiled banner to the Amphitheater to receive homage. Camaraderie prevails throughout the week as alumni convene for their annual class reunions. (Courtesy of John Cofield.)

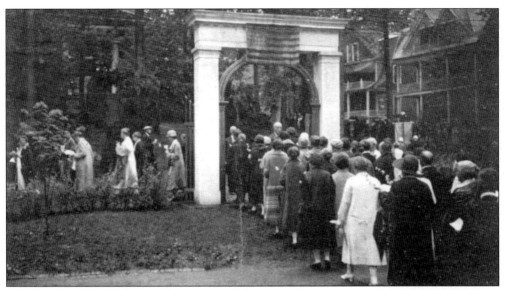

Numbering just over 200 graduates, the Chautauqua Literary and Scientific Circle Class of 1928 chose as their honoree Jesse L. Hurlbut, who assisted with the operation of the CLSC. The graduates are seen as they enter through the Golden Gate at the rear of the Hall of Philosophy on Recognition Day. In another ritual, the gate was unlocked by the "Keeper of the Gate" so that the prospective graduates were admitted into the hall to receive their coveted diplomas. (Courtesy of Deb Blodgett.)

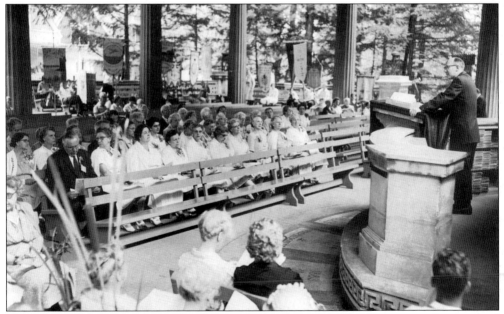

This photograph was taken in the Hall of Philosophy during the Chautauqua Literary and Scientific Circle Recognition Day ceremony on August 6, 1958. Of the 70 graduates in the class, 40 attended and heard an address by Jonathan Daniels, editor and publisher of the *Raleigh News and Observer*. The mosaic floor tiles in front of the lectern were designed by early CLSC classes. In the background are several banners from previous CLSC classes that are annually displayed in the traditional procession. (Courtesy of the CLSC Alumni Association Archives.)

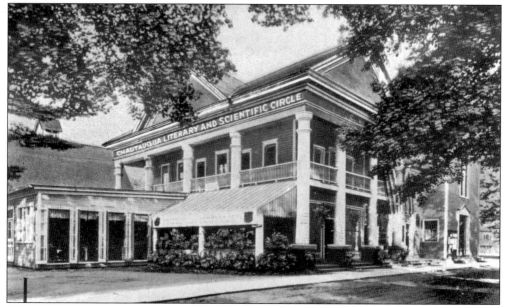

The two-story pillared Chautauqua Literary and Scientific Building was a gift of Theodore L. Flood and George E. Vincent, son of John Heyl Vincent, in 1890. As partners of the Chautauqua Press, they recognized the need to bring Kate Kimball and her staff to a suitable office at Chautauqua. The building's location in the heart of the grounds validated the esteem and importance of the CLSC to the entire Chautauqua concept.

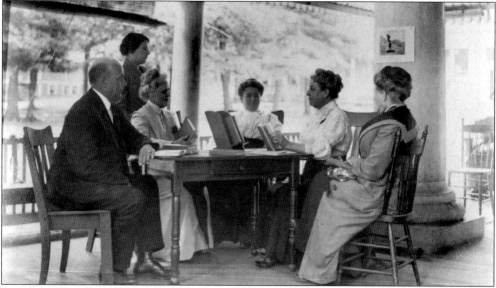

Shown here on the first Chautauqua Literary and Scientific Circle veranda, one of the largest porches on the grounds, are Mrs. S.H. Day, the "Lady of the Veranda," and some friends. The CLSC Building was located behind the current site of Smith Memorial Library on Clark Avenue. Books, tea, and hospitality were served to passersby, who were urged to browse through CLSC book selections. When moved to the small Victorian annex of the former Administration Building on the Brick Walk, the CLSC office became more visible and more conducive to book and membership sales and was the perfect location for autograph sessions.

The unique Octagon Building, located beside Pioneer Hall, was built in 1885 by Chautauqua Literary and Scientific Circle members from the Pittsburgh area. In 1889, it was acquired by the CLSC Classes of 1883 and 1885 as their meeting site. Chautauqua author Rebecca Richmond founded the Writer's Workshop in the early 1940s and, at her invitation, noted novelists and poets conducted classes and seminars in the building. The 1973 visit of author John Ciardi, director of the prestigious Middlebury College Writer's Conference in Vermont, provided additional recognition to Chautauqua's expanding literary programs.

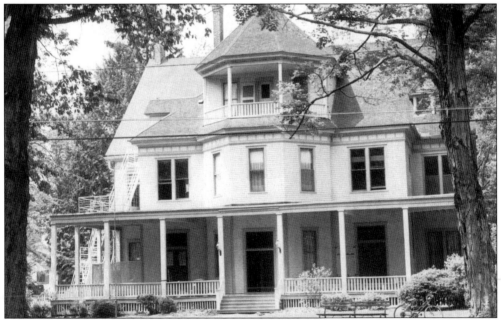

Alumni Hall was built in 1892 and has been the hub of all Chautauqua Literary and Scientific Circle activities. Maintained jointly by the institution and CLSC alumni dues and gifts, its spacious veranda, inviting chairs, and parlors have always provided a welcome center for CLSC graduates. Alumni Hall is located near the Octagon Building, Pioneer Hall, the Hall of Christ, and opposite the Hall of Philosophy; this section of the grounds is regarded as the heart and center of the CLSC. (Courtesy of *The Post-Journal*, Jamestown, N.Y.)

One of the original bells at Chautauqua was the Bryant Bell in the Pier Building Tower. It was named in honor of the poet William Cullen Bryant, a strong advocate of John Heyl Vincent's reading course. It has annually tolled the arrival of the new Chautauqua Literary and Scientific Circle reading year during the Bryant Day ceremony. (Courtesy of the *Post-Journal*, Jamestown, N.Y.)

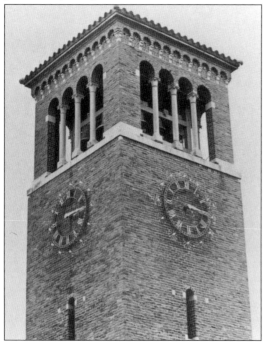

The Bryant Bell was purchased for the specific use of the Chautauqua Literary and Scientific Circle and the summer school assembly. It remained in the Pier Building Tower from 1886 until its transfer to the carillon in the Miller Bell Tower Campanile in 1911.

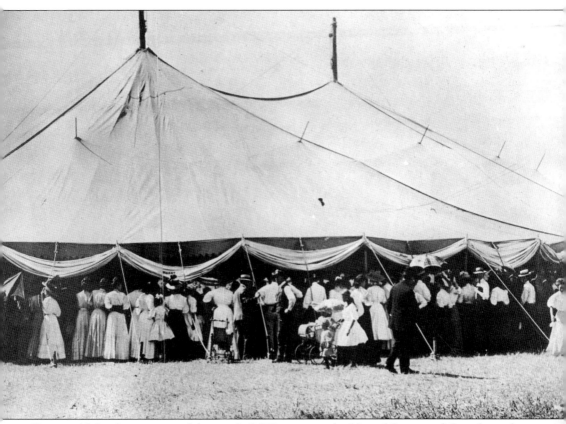

Kearney, Nebraska, was one of the nearly 8,500 towns in the United States and Canada on the "tent chautauqua" circuit. Although these chautauquas were unconnected and operating beyond the control of the original Chautauqua (capital C), many Americans vividly recall their personal experiences when the traveling shows came to town. Noted women's rights advocates such as Susan B. Anthony, Anna Howard Shaw, and Carrie Chapman Catt made the rounds, but the eloquent William Jennings Bryan was undoubtedly the most visible and active participant. This spellbinding orator used the circuit platform to advocate for prohibition, suffrage, and a variety of other political agendas. These shows helped popularize "Mother Chautauqua," the role model for the expansion of culture into rural communities. Although the goals of the promoters varied, obvious similarities existed. Thousands flocked to the tents, advertising "opportunities" for education, entertainment, culture, and inspiration. Platform programs informed attendees of current issues and topics for their individual betterment.

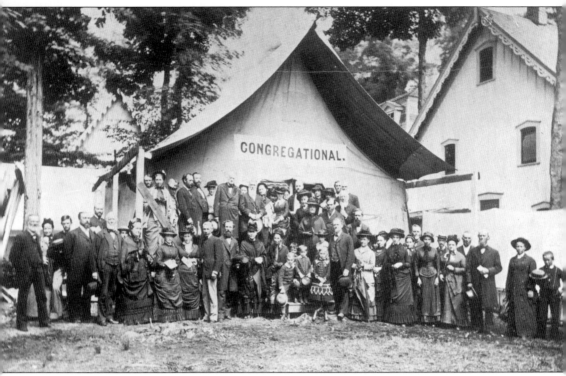

Built in 1882, the Congregational House was the first denominational building at Chautauqua. It later became the main headquarters for the United Church of Christ.

Three

RELIGION, EDUCATION, AND RECREATION

Founded as a camp meeting for Sunday school teachers, religion and a religious spirit are fundamental to the Chautauqua concept. Despite its Protestant heritage, the Chautauqua Institution takes pride in its ecumenical programs that minister to the needs of all visitors. The major denominations have houses or headquarters at Chautauqua that serve as hospitality centers and places of worship.

During the second Chautauqua Assembly in 1875, religious classes expanded to include the study of Hebrew. In 1882, the chaplain-of-the-week program began; daily devotional exercises continue to be led by clergy who not only preach on the Sabbath but often lecture or teach religion during their week's stay. Moreover, after the formation of the School of Theology, religious training was available for candidates for the ministry and enrichment study for clergy. According to former historian Alfreda L. Irwin, Chautauqua's religious program was "both inspirational and educational and consistent with Dr. Vincent's goals," as indicated by the motto of the Chautauqua Literary and Scientific Circle: "We study the Word and Works of God."

In his book *The Chautauqua Movement*, John Heyl Vincent stated: "Education, once the peculiar privilege of the few, must . . . become a valued possession of the many." Since both Miller and Lewis agreed that all learning was sacred, the emphasis on Bible study and religion was expanded to include classes in languages, sciences, and normal school studies.

In 1876, special interest groups, including a church congress, a scientific conference, and a temperance conference, convened on the grounds. In addition, the Chautauqua Schools of Languages and Music took root, and a Teacher's Retreat of distinguished scholars from all over the country was founded. The very first summer school program in the United States is reputed to have originated at Chautauqua in 1879.

To consolidate the rapidly growing academic programs, a central organization was needed; as a result, the New York State legislature granted the newly created Chautauqua University the right to confer degrees. Lewis Miller assumed the role of university president, and John Heyl Vincent became university chancellor.

In 1902, when Chautauqua University was renamed the Chautauqua Institution under a new state charter, the name Chautauqua Assembly was retained when referring to the summer season. The educational institution's stated purpose was "to promote the intellectual, social, physical, moral, and religious welfare of the people."

Chautauqua's growth continued and, by 1924, its summer school catalog boasted 18 departments of instruction with more than 120 faculty members and some 2,000 registered students, young and old. Affiliated at one time with New York State University and Syracuse University, Chautauqua provided the opportunity to earn course credits, and offerings adapted to the changing times. In 1945, after World War II, students could enroll in classes as diverse as lip reading, narcotics education, and "The Veteran on the Home Front."

Religious and academic course offerings were complemented by the establishment of the Physical Education Department c. 1886 to promote healthful exercise to develop strong bodies along with intellect. A skating rink, tennis courts, a track, a baseball diamond, and a lakefront bathhouse were available for boys and girls. The Chautauqua Boys' and Girls' Clubs are thought to be the oldest continuous day camps in the United States. Although they usually met separately, both genders had experienced instructors and well-equipped facilities in a relaxed and safe environment.

In its more recent brochures, Chautauqua advertises its vacations as "an extraordinary blend of arts, programming, and recreational activities for personal enrichment and renewal." Yet, recreation is more than mere relaxation. In 1918, an article in the *RoundTable* stated that Chautauqua's setting and programs enabled a participant to become "fit for the work of the year" so that he might leave stronger and be "re-created in all his forces." And, a vacation, as John Heyl Vincent so aptly noted, "need not imply vacuity of mind."

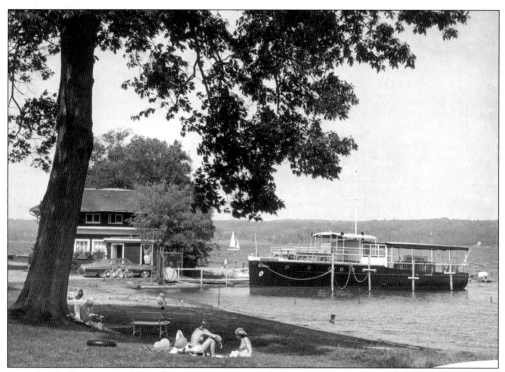

The *Gadfly II* was brought to Chautauqua Lake and, beginning in 1947, it left the Chautauqua Institution dock for scheduled passenger service. (Courtesy of the *Post-Journal*, Jamestown, N.Y.)

In 1916, a contemporary remarked that "Bishop Vincent and Dr. Hurlbut were often seen together at Chautauqua strolling arm in arm over the grounds so dear to both of them." Jesse L. Hurlbut began as John Heyl Vincent's associate in the Sunday school and returned every summer for 50 years. He supervised the normal school, formed the adult Bible class, and lectured in Palestine Park.

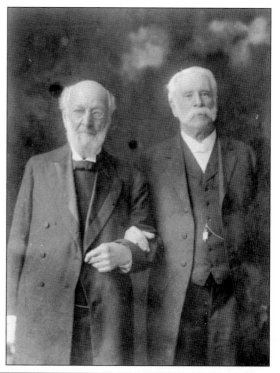

The Hurlbut Memorial Church, named to honor Jesse L. Hurlbut, was founded by the Methodists and began as a small chapel in 1876. The present church was completed in 1931 and has served the Chautauqua community not only in the summer but year-round. Edgar C. Welch, president of the Welch Juice Company, was an active member and treasurer of the church's building fund. (Courtesy of the *Post-Journal*, Jamestown, N.Y.)

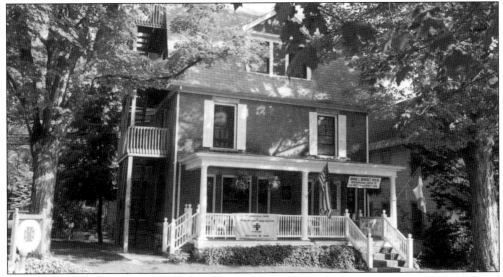

The International Order of the King's Daughters and Sons is an interdenominational organization of Christian men and women dedicated to Christian service. It owns a chapel and three residences on the grounds to accommodate students and staff. It promotes the highest ideals of Christian living and sponsors a program that emphasizes spiritual growth, education, academics, philanthropy, and social graces. In 1919, Mina Miller Edison assisted a group of women to organize the Chautauqua Chapter, which takes enormous pride in its 80-year-old scholarship program. (Courtesy of Jane Currie.)

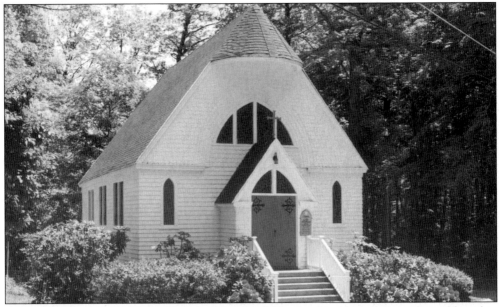

Prior to the completion of the Chapel of the Good Shepherd in 1894, Episcopalians, like other denominations, held services in a tent. The chapel's diminutive size, steep-pitched roof, and hooded entry make it distinctive. The stained-glass windows behind and to the side of the altar were in the original structure. Worshippers of all faiths flock to the simple chapel near the Hall of Christ for weddings, baptisms, Communion, healing services, and private meditation. (Courtesy of Jane Currie.)

The Lutheran House, located on the Brick Walk between the Chautauqua Amphitheater and the Hall of Philosophy, was dedicated in 1925. It is easily identified by its brick exterior and distinctive arches, reminiscent of Roman aqueducts. From its beginnings in 1890, when Lutheran worship was held at a private home, the group has maintained a steadfast mission: to make the headquarters a common meeting place for all Lutherans, regardless of nationality, language, or synod affiliation. Worshippers and boarders enjoy the communal atmosphere.

The United Methodist Missionary House is an impressive vacation home located on the lakefront near the Women's Club and the Athenaeum Hotel. It was once the summer residence of Clement Studebaker, who served briefly as Chautauqua's president after the death of cofounder Lewis Miller. The structure is an outstanding example of Dutch colonial motif, and the interior is well maintained with its mission oak woodwork. It is a popular denominational guesthouse, as one would imagine. (Courtesy of Jane Currie.)

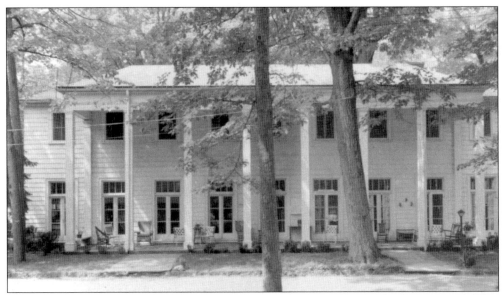

The Hall of Missions, with its colonial Mount Vernonish facade, was built in 1924 and has served as the social headquarters of the Department of Religion for faculty, staff, and missionaries. Young people benefited from the popular Globe Club meetings, under the auspices of the Department of Religion, which introduced them to missionaries and, in turn, to issues of international concern.

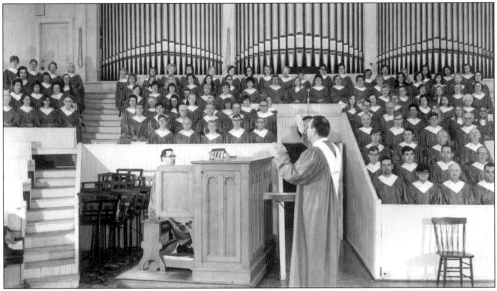

The Chautauqua Choir, a volunteer assemblage dating back to the first Chautauqua Assembly, performs at the Sunday worship service, the daily morning worship service, and at the sacred song service. Excellent directors, outstanding organists, and frequent rehearsals enable this group to blend and perform as professionals. The choir voices are augmented by the Massey Memorial Organ, built in 1907. This unique outdoor organ, used in the open-air Chautauqua Amphitheater, has 5,628 pipes set in 93 rooks; its pipe chamber is three stories high and produces exquisite sound. It was donated by the Massey family of Toronto, and its original cost of $40,000 has spiraled to a value of nearly $2 million.

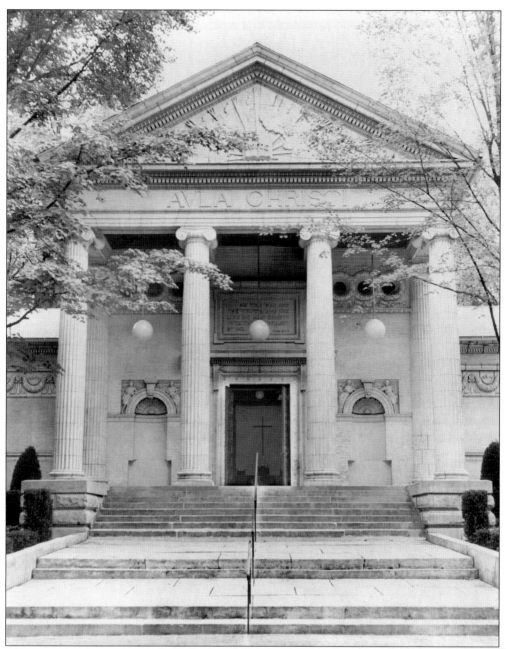

The centralized location of the Hall of Christ on the grounds symbolizes the commitment of John Heyl Vincent and of the Chautauqua Assembly to religious worship and study. The building was designed in 1907 by Paul J. Pelz, an architect involved in the creation of the Library of Congress. Its impressive portico atop the massive staircase overlooks the former St. Paul's Grove. The white terra-cotta and fluted Greek columns are adorned with secular and religious symbols from the Bible and Greek mythology. Since its renovation in 1967, it has become a popular wedding location.

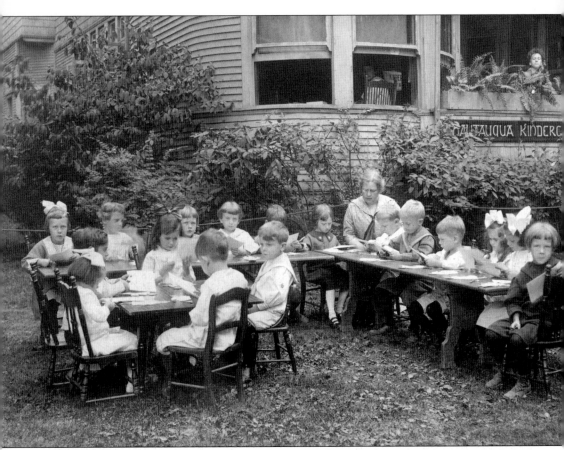

This photograph of the kindergartners sitting outside Kellogg Hall was taken in 1913. At the far left with a bow in her hair is Mary Frances Bestor, daughter of Arthur E. Bestor, president of Chautauqua. John Dewey of the University of Chicago was director of the Vacation School at Chautauqua. His progressive educational theories emphasized the intellectual and physical development of every child. In a nontraditional style, children were taught "to play with a purpose and to learn with a purpose" under skilled supervision. Much time was spent outdoors to help develop a healthy, well-rounded individual. The first Chautauqua playground, designed by Jacob Riis, was equipped with climbing apparatus, sandboxes, swings, and slides. (Courtesy of Mary Frances Bestor Cram.)

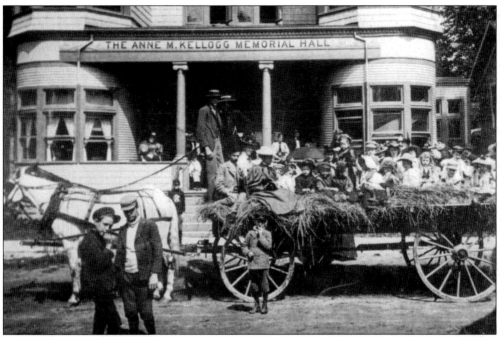

This kindergarten hayride, a favorite activity, was photographed in 1889 in front of Kellogg Hall. Children made paper bonnets to prevent sunburn, a typical hands-on activity of Chautauqua's progressive school under the direction of John Dewey. The hall that housed the kindergarten, the stepping-stone to the Boys' and Girls' Clubs, was a tribute to the mother of James K. Kellogg of Troy, who was a patron of the arts and an advocate of women's rights.

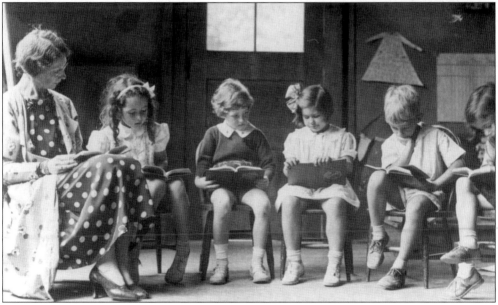

In 1905, Frank Chapin Bray called Chautauqua a "children's paradise." Young children were provided opportunities for constructive activity within a structured framework. In addition to reading, even the youngest of children was encouraged to participate in handicrafts, puppetry, story hours, swimming, music, and drama.

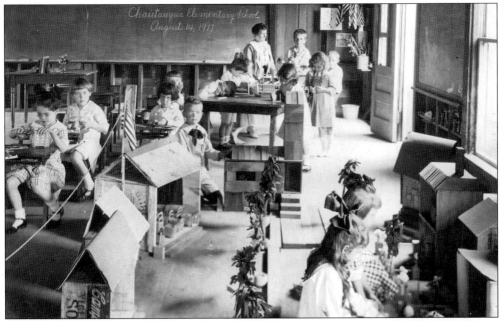

Pictured is the combination grades three and four classroom at Chautauqua Elementary School, outside the grounds. Mary Frances Bestor Cram remembers her class constructing a replica of Chautauqua's buildings and streets in Miss Prendergast's class. The School of Education prided itself on being a demonstration school for parents, teachers, and children, much like contemporary learning labs. (Courtesy of Mary Frances Bestor Cram.)

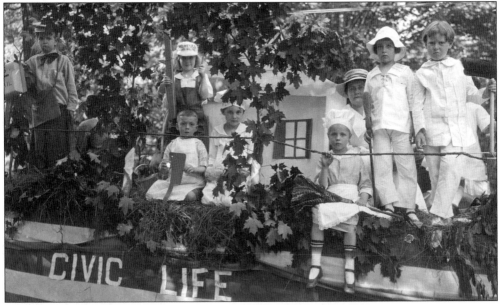

This Civic Life float, c. 1918, traveled throughout the grounds and is indicative of John Dewey's modern and somewhat radical educational system. Children assumed the roles of occupations existing in the local community and paraded in their various costumes. Special events like these often ended at the athletic field with accompanying ceremonies. (Courtesy of Mary Frances Bestor Cram.)

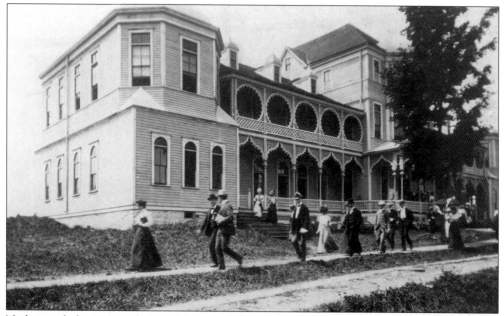

Nicknamed the "Moorish Barn" because of its turrets and exotic rooflines, the College of Liberal Arts building was constructed to replace tents and small structures that had been physically outgrown by the burgeoning educational programs. It was built in the late 1880s, when William Rainey Harper assumed the supervision of the college, and it was razed in 1919.

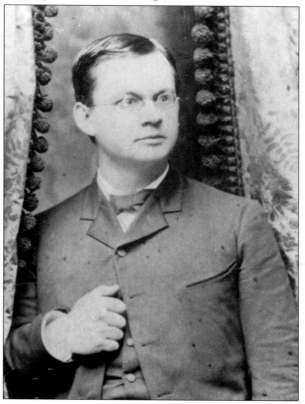

Because John Heyl Vincent anticipated the growing rivalry of the Baptist assembly across the lake, he arranged to hire William Rainey Harper of Yale University to teach Hebrew at Chautauqua. As head of the Chautauqua Summer Schools from 1885 to 1898, Harper established an impressive reputation in the field of education, as did other members of the faculty, including presidents from Cornell University, Amherst College, the University of Wisconsin, and professors from scores of prestigious universities. When Harper was named president of the University of Chicago, he tried unsuccessfully to incorporate much of the Chautauqua plan into the university's curriculum.

The College of Liberal Arts Building, which served the needs of summer school students for many years, was replaced by the Arts and Crafts Building. Courses offered included painting, drawing, handicrafts, metal craft, jewelry making, and weaving—held in various studios in the quadrangle.

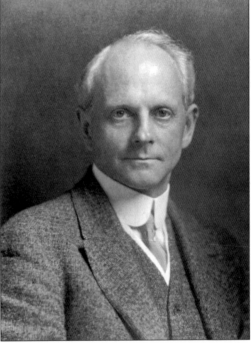

Henry Turner Bailey designed the Arts and Crafts Building and headed the summer school arts and crafts program before being named dean of the Cleveland School of Art. He was both an art educator and an artist enamored with beauty, "looking for [it] everywhere; watching for it, searching for it in the great and in the small, in the unusual, and in the commonplace things of this wonderful world."

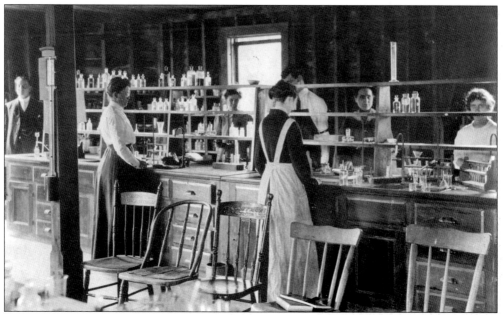

Women began exploring the sciences at Chautauqua as early as 1885, when chemistry classes were held in the College of Liberal Arts. Experiments constituted a large portion of the curriculum.

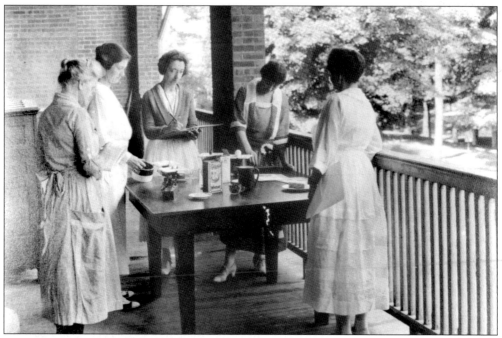

These women are taking a domestic science course, similar to the one in which Jeanette Lemon Bestor enrolled in 1905. The wife of the future Chautauqua Institution president, she took the course during the first year she lived at Chautauqua and later attributed many of her hostess and hospitality skills to lessons learned in that class.

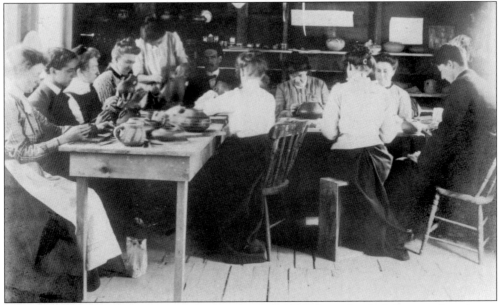

Instruction was offered in almost every artistic medium in the individual shops and studios in the Arts and Crafts Village. This is a clay modeling class held in a second-floor room of the building. Other courses held in the quadrangle were art metal, glass, leather goods, beadwork, and bookbinding. A pottery kiln was also available for student use. (Courtesy of the Adelaide L. Westcott Scrapbook, Chautauqua Institution Archives.)

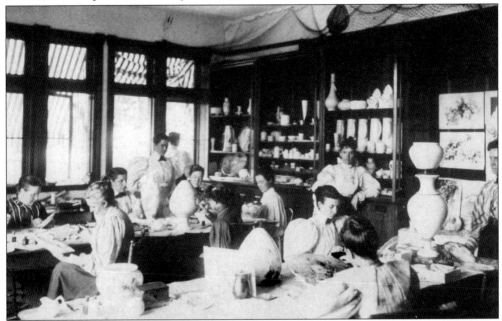

Before the permanent village was built, the temporary Arts and Crafts Village was composed of eight frame buildings and two tents near the Main Gate. Enclosed with a lattice fence, it became a small community within the greater Chautauqua community. This 1896 photograph captures a class engrossed in china painting. Women of leisure were the major arts and crafts enrollees, seeking "a pastime and an accomplishment."

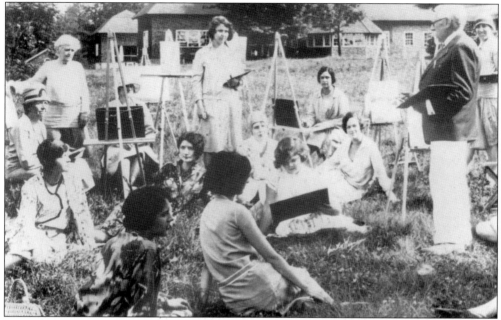

Revington Arthur, longtime painting instructor in the Chautauqua School of Art, influenced his many students. His theory that painting was "strictly feeling" must have impacted psychiatrist Karl Menninger, too, for the latter painted with Arthur during his occasional lecture visits.

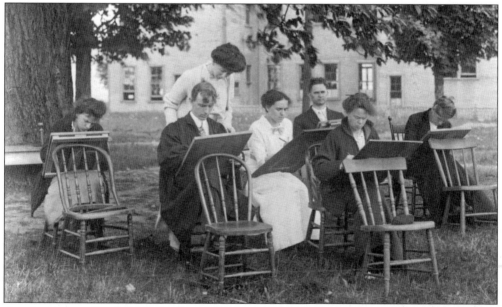

Art classes were first held in the Pier Building in the early 1880s, and students could enroll in sketching, painting, and clay modeling classes. Later, painting and craft studios were located in the Arts and Crafts Quadrangle. Since 1952, the Chautauqua Art Association, an independent organization, has fostered the love of art, holding exhibits and lectures and sponsoring a National Jury Show and the Bestor Plaza Art Festival. The outdoor festival features paintings, graphics, sculpture, ceramics, weaving and textiles, photography, and young people's art.

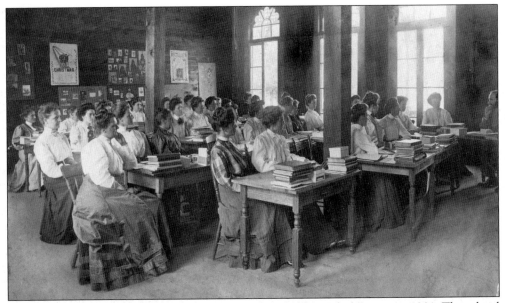

The Chautauqua School of Library Science was founded by Melvil Dewey in 1901. The school was a separate department of the Chautauqua Summer Schools and was designed for workers in small libraries, who could not take a leave of absence from their positions to acquire the necessary training to attain professional status. This concentrated summer study program enrolled learners according to their levels in different curricula, providing them with not only theory but also actual experience in a library setting.

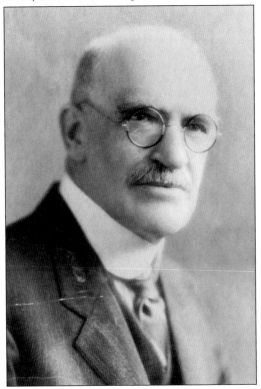

Melvil Dewey, a graduate of Amherst College, played an important role at Chautauqua. He was interested in Chautauqua's expanding system of education and thought its wealth of educational and intellectual opportunities made it the ideal location for the training of librarians. Contrary to popular belief, the Dewey decimal classification—the catalog system that bears his name—was created prior to his Chautauqua connection. Dewey served on the library's board of trustees from 1907 until his death in 1930.

In 1931, Mrs. A.M. Smith Wilkes willed $69,000 for the construction of the Smith Memorial Library in memory of her parents, one of two buildings she gave to Chautauqua. It serves the community year-round as a free public library. It was and remains the home of the Chautauqua Institution Archives, including all Chautauqua Press publications dating back to 1876. The donor stipulated that her personal books, journals, and objets d'art collected during her global travels be stored there. Once located in the College of Liberal Arts Building, the School of Library Science moved to the second floor of Smith Memorial Library, a site more conducive to its purpose. Blending with the library's architecture is the Mrs. Joseph H. Roblee Memorial Garden behind the building, honoring her dedication to the Bird, Tree and Garden Club. Designed around the Japanese maple and surrounded by a low brick wall, the garden includes perennials, annuals, rocks, and a small pool and borders the Brick Walk near the Chautauqua Amphitheater. (Courtesy of the *Post-Journal*, Jamestown, N.Y.)

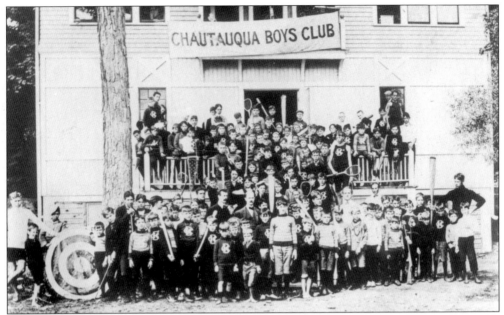

Built in the late 1800s, the Chautauqua Boys' Club was frequented by males ages 7 to 16. Games, sports, and other competitions occurred in the indoor area, out on the playground, on the athletic field, and at the lakefront. Competent and dedicated counselors from all over the country and outside its borders—many of them former club members themselves—returned each year. Under their able supervision and instruction, children could participate in a variety of activities while their parents had the convenience of attending daily lectures and classes.

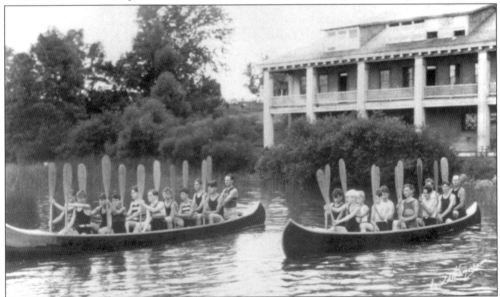

In recent years, the youth clubs have emphasized waterfront activities: swimming, boating, lifesaving techniques and, as evident above, canoeing, in particular. Both boys and girls, through the organized club programs, are encouraged to develop their physical and mental abilities by participating in camping, hiking, gymnastics, drama, woodcraft, dance, art, music, nature appreciation, archery, and crafts.

By the early 1900s, students from nearly every American state and territory, Canada, England, and India were enrolled in the summer programs run by the Department of Physical Training. Although these young people were together for only the summer months, the camaraderie fostered by membership in the Boys' and Girls' Clubs evolved into many lifelong associations and friendships. (Courtesy of the Samuel M. Hazlett family.)

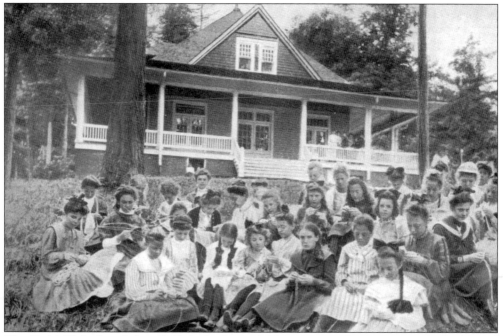

The Girls' Club, founded in 1902, had a large clubhouse set in the forest near the beach and lake. Girls, ages 8 to 16, participated in French, German, weaving, folk dancing, cooking, sketching, drama, speech, and music. These girls are taking a basketry class. In the early years, young women were allowed only limited participation in a number of physical sports. (Courtesy of the Samuel M. Hazlett family.)

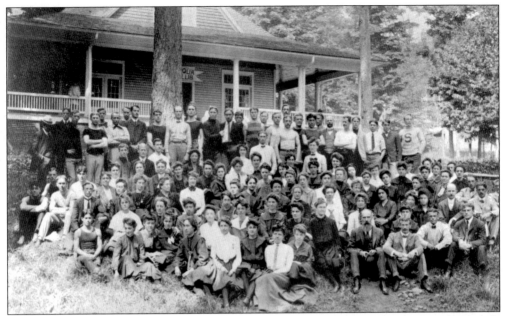

Jay Seaver, the head of the Chautauqua School of Physical Education, was credited with pioneering the idea of physical education within an academic curriculum. He is pictured in front of the clubhouse in 1910, with a long beard, in the front row near the right-hand side. The Swedish Gymnasium, the original gym of 1890, was renamed in his honor. (Courtesy of the Samuel M. Hazlett family.)

The Beeson Youth Activities Center was dedicated in 1968 in memory of Chautauqua trustee Charles Beeson. It replaced the demolished Athletic Center. The new building is the headquarters for both the Boys' and Girls' Clubs, dealing with young people from 6 to 15 years old. It contains a game and recreation room, craft and special studies classrooms, administrative offices, and some living quarters.

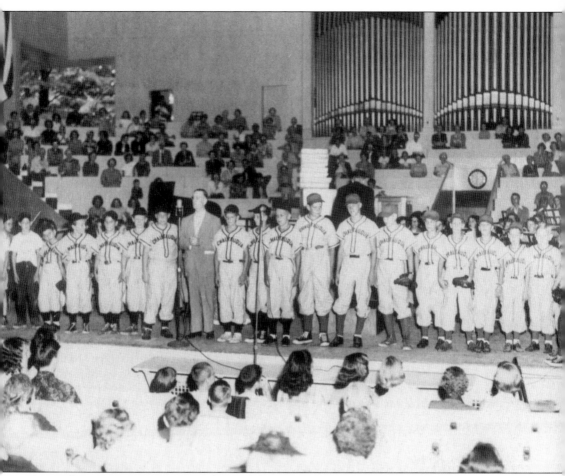

As in all American communities, baseball has always been a favorite at Chautauqua. It was played at the Albert H. Sharpe Athletic Field, which was dedicated in 1965 to honor the respected Chautauqua coach who went on to become Yale University's football coach and athletic director. Shown above, at a ceremony on the Chautauqua Amphitheater stage, is Pres. Samuel M. Hazlett, center, addressing Boys' Club members involved in Little League baseball. Tennis, another popular Chautauqua sport, was reputed to have been brought to Chautauqua by cofounder John Heyl Vincent, who discovered lawn tennis on a trip to England. In 1878, one of the first courts in the United States was set up between Vincent's cottage and the Chautauqua Arcade on the lakefront. (Courtesy of the Samuel M. Hazlett family.)

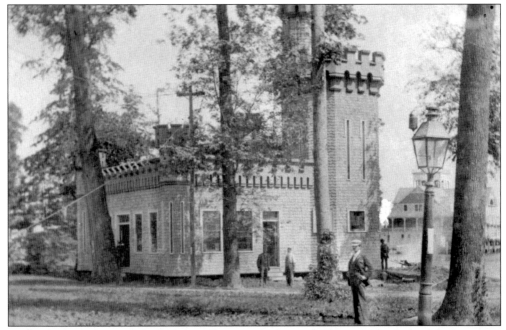

The castlelike electric light and powerhouse, which was built in 1893 on the lakefront, was converted into a men's clubhouse c. 1903. The $5,000 remodeling cost included the installation of reading, writing, and smoking rooms, a barbershop, showers, a roof garden, and a spacious veranda. All men on the grounds were welcome, and organizations such as the Masonic Lodge were encouraged to hold meetings there. (Courtesy of the Samuel M. Hazlett family.)

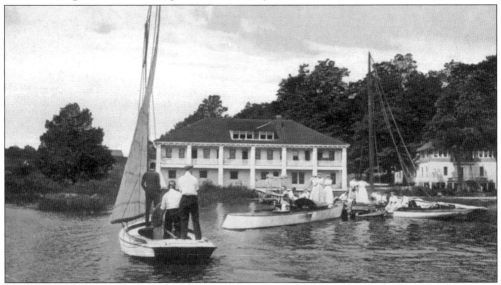

In 1931, the lakefront Men's Club was dissolved and replaced by the Chautauqua Yacht Club, which fostered boat races of all sorts. Shortly afterwards, the Yacht Club and the Horseshoe Club merged, and the new Sports Club opened in the early 1940s. Indoor activities included bridge, pool, and billiards. Membership in the Sports Club was eventually opened to women, too, and it became a busy social center, with well-used shuffleboard courts. (Courtesy of Kathleen Crocker.)

The School of Physical Education program devised by Jay Seaver included men's calisthenics as an integral part. While on the faculty of Yale University, Seaver kept a physical record of each of his students; this innovative approach demonstrates Seaver's belief in the development of the whole body.

Perhaps these men, who are skull racing, were members of the College Club, which sponsored programs and activities for young people ages 18 to 25. Their clubhouse was located in the Pier Building, where they organized a variety of programs including dances, stunt nights, picnics, bridge, and swimming parties.

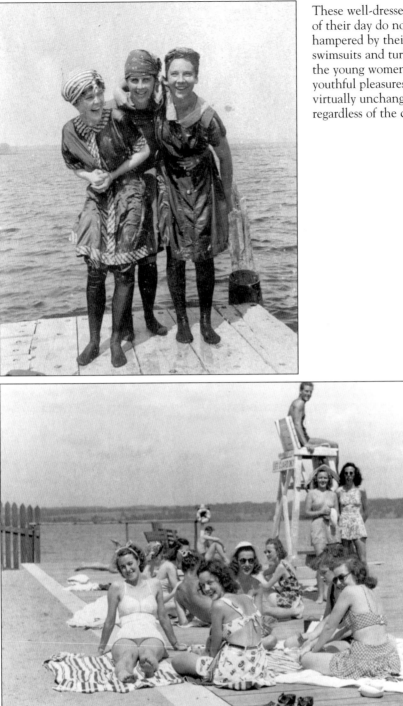

These well-dressed young bathers of their day do not seem to be hampered by their cumbersome swimsuits and turbans. Just like the young women below, youthful pleasures remain virtually unchanged; fun is fun regardless of the calendar date.

Activities were available for young people of all ages at Chautauqua. After schooling in the kindergarten and then the Boys' and Girls' Clubs, the High School Club next provided sports, service projects, and leadership training. These teenagers, however, seem to be concentrating on their social skills at the moment.

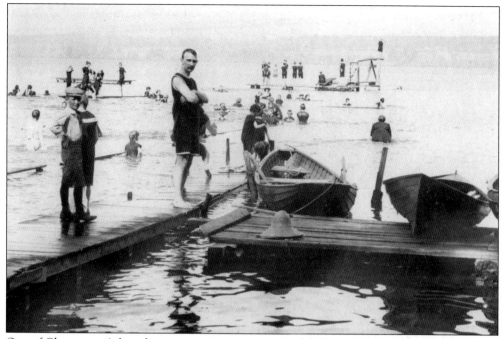

One of Chautauqua's best features remains its expansive lakefront. The sandy public beach was a summer paradise. With no swift current, sinkholes, or whirlpools to fear, swimmers, sailors, and fishermen could wholeheartedly enjoy outdoor pursuits.

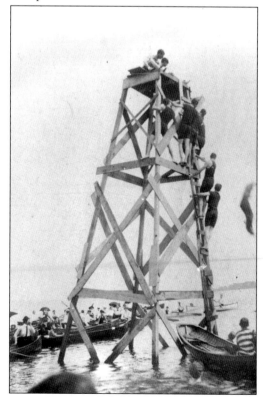

This diving platform was a popular place to meet and relax. Although swimming and diving lessons were provided by skilled instructors, informality often prevailed. It should be noted that for many years swimming and a number of other activities were verboten on Sundays at Chautauqua.

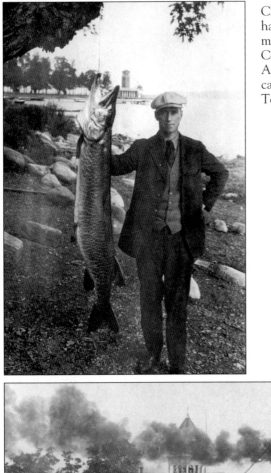

Chautauqua Lake was stocked by a local fish hatchery with angler's favorites: muskellunge (muskies) and bass. Lawrence Cornell, a former manager of the Athenaeum Hotel, is nearly dwarfed by his catch as he poses near the Miller Bell Tower dock.

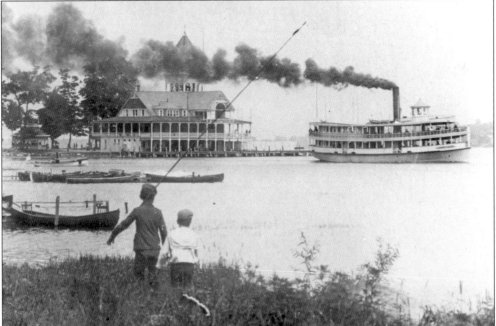

Regardless of age, Chautauqua Lake fishermen have always longed to take home muskies, bullheads, and smallmouth and largemouth bass. Chautauqua County maps, furnished free of charge, indicated the best fishing spots on the lake to entice vacationers and encourage tourism. In the winter months, skating and ice fishing were popular sports for locals and visitors.

76

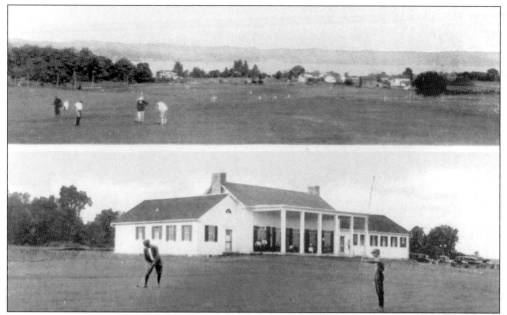

A six-hole golf course at Chautauqua was started on the Prendergast family pasture in 1898. An 18-hole course was designed by Donald J. Ross of Pinehurst, North Carolina, and opened in 1924. Premier golfers such as Walter Hagen, Byron Nelson, Sam Snead, and Ben Hogan have enjoyed its splendid fairways and greens, the spectacular lake view, and the spacious clubhouse. It remains a vital component of the Chautauqua experience for both vacationers and visiting dignitaries.

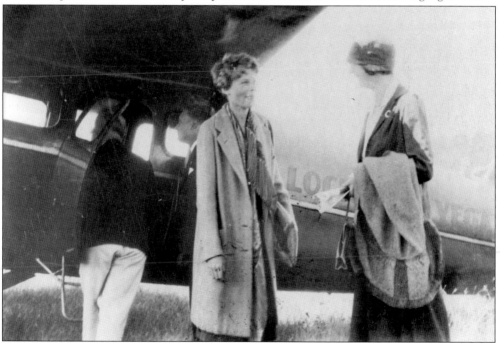

Pictured with Mrs. Arthur E. Bestor is Amelia Earhart, center, after she flew her Lockwood Vega from New York City to Chautauqua in July 1929. Earhart's scheduled landing was made on the 14th fairway of the Chautauqua Golf Course.

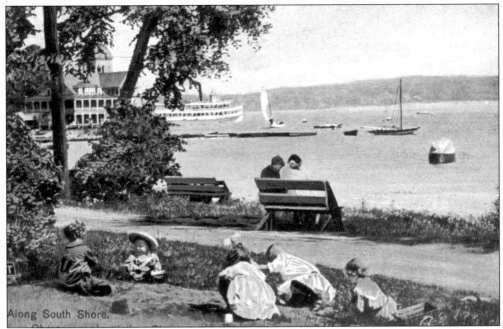

The combination of quality instructional and recreational programs in an idyllic setting enticed families to the grounds and, inevitably, led to the Chautauqua Assembly's overwhelming success. Chautauqua's beauty was conducive to both work and play for every member of the family. (Courtesy of John Cofield.)

Frank Chapin Bray thought Chautauqua to be "a vacation school of life for the family." With its temperate climate and lakefront setting, several generations of family members have chosen Chautauqua as their ideal vacation spot.

Four

COMMUNITY
AND CIVIC PRIDE

The expansion of educational offerings, programs, and events increased attendance at Chautauqua. Consequently, Chautauqua began to resemble a community whose residents shared mutual interests, concerns, and quests for fulfillment. Families, not just individuals, returned each summer in pursuit of self-improvement at the lakeside setting. In time, generations of families sojourned to their secondary residence, eager to renew associations of the past.

By the end of the 19th century, almost every amenity was provided for the "excursionists," a label given by Frank Chapin Bray in A Reading Journey Through Chautauqua, published in 1905. Hotels, guest rooms, apartments, and single rooms were quickly booked and, as is true today, best reserved in advance. Some provided light housekeeping and kitchen and dining privileges. Several restaurants, cafeterias, and tearooms catered to those who dined out.

The Colonnade Building once housed merchants, the post office, the Chautauqua Press, and administrative offices; residents found it the ideal business center. Like the typical town square, residents gathered there to socialize as well.

No longer a mere summer colony, Chautauqua grew and incurred larger expenses as the 20th century progressed. Two administrations in particular were invaluable to Chautauqua's preservation. The presidencies of Arthur E. Bestor (1915–1944) and of Samuel M. Hazlett (1947–1956) literally saved Chautauqua from financial ruin. With their sound management skills, personal loyalty and dedication, and their ability to muster confidence and support from the Chautauqua community, these two leaders enabled Chautauqua to resume operation on a sound fiscal basis. For the first time, previously leased land was offered for sale.

By the early 1900s the Chautauqua "family" had evolved. Community residents, both individuals and organizations, pooled their talents and resources to ensure that Chautauqua and its mission would prevail. Taking great pride in the accomplishments of previous generations, residents felt it their civic duty to help preserve the past for the future.

After the resignation of George E. Vincent, Bestor began his tenure as Chautauqua's longest-

serving president. With degrees from the University of Chicago and Colgate University, he was a historian, a political scientist, and an accomplished lecturer, often in demand for his views on European and Middle Eastern politics. He had an international reputation as a scholar.

Continuing the founders' vision, Bestor developed a keen interest in adult education for both men and women. He believed that Chautauqua's mission was to continue to foster that facet of the Chautauqua Idea to "prepare individuals and organizations to play their full part in the life of this country in this day of changing ideals and new standards."

In 1917, Bestor was appointed by Pres. Woodrow Wilson to chair a committee to coordinate the various independent speaking campaigns on war relief. During the war years, Bestor utilized the Chautauqua platform for the open discussion of organized peace, encouraging every Chautauquan to broaden his awareness of the war issues. He believed "in education as the indispensable ingredient in winning the war" and "hoped that Chautauqua might go beyond an intellectual appreciation of problems to a point where it could furnish the moral and spiritual dynamic" to prevent further wars.

Precipitated by the Depression, the Chautauqua Institution was forced into financial receivership. In order to liquidate its debts, Samuel M. Hazlett, a Pittsburgh attorney and a devoted Chautauquan, was named president of the Chautauqua Reorganization Corporation charged to raise sufficient funds to ensure its survival.

Hazlett spearheaded a group of Chautauqua volunteers to meet the crisis. Appealing to friends of Chautauqua to give "thank-offerings" and "their generous subscription," he did so "in the name of progress of the human race and in the interests of those cultural, civic, social, moral, and religious influences which Chautauqua generates and releases in the minds and hearts of multitudes."

Memorials, endowments, and personal service characterized Chautauqua from its inception. At the annual Old First Night gala held to celebrate the first Chautauqua Assembly of 1874, Chautauquans outwardly demonstrated their loyalty and affection. Following the opening vesper service in the Chautauqua Amphitheater, identical to the original one in the early auditorium, activities included the recognition of families and their tenure and the roll call of states. The most solemn part of the ceremony has always been the "Drooping of the Lilies," which acknowledged the founders, former Chautauqua presidents, and all departed Chautauquans by the raising and lowering of handkerchiefs.

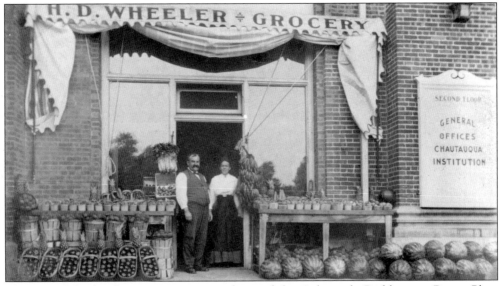

The H.D. Wheeler Grocery store operated out of the Colonnade Building on Bestor Plaza through the mid-1940s. The family had previously managed a farm outside the gate.

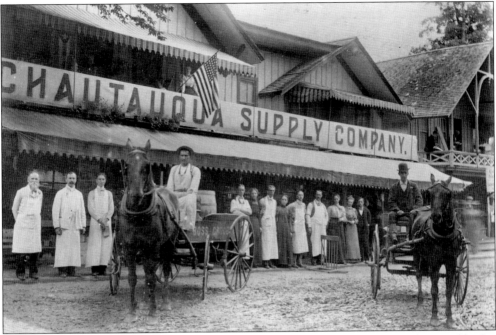

Most of the first businesses, conducted from tents in the Miller Park area, were destroyed by fire in 1889. The central business district then moved up the hill to Vincent Avenue. This street, at one time, continued through the present Bestor Plaza area. The Chautauqua Supply Company faced Vincent Avenue, as did a meat market and milk depot, all fronted by a board platform for customer convenience.

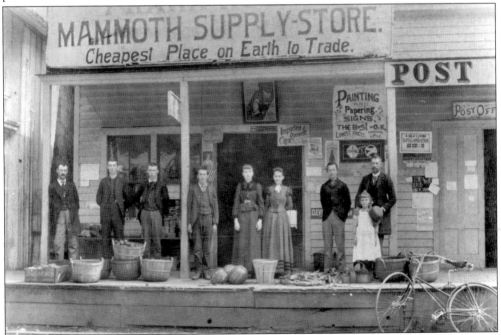

The Mammoth Supply Company and the post office were side by side in the same business block. These businesses burned in 1904.

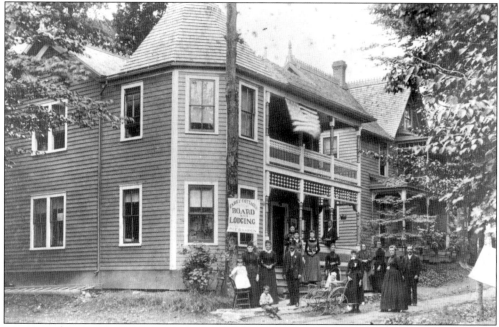

This is a photograph of the original Cary Cottages Board and Lodging establishment *c.* 1900. Many buildings were connected to accommodate guests, the most famous of whom was American composer and musician George Gershwin.

Workers pose outside the St. Elmo Hotel, built *c.* 1890. The hotel began as a family inn and, despite many renovations throughout the years, managed to retain a certain old-world charm. From a single building it eventually grew to occupy an entire block on the central plaza. Many cottage owners, rather than opening their seldom-winterized homes, spent weekends and holidays at the St. Elmo, which became a community center open year-round. Today, the St. Elmo consists of several condominiums.

In the late 1890s, owner Jesse L. Hurlbut sold what later became the Gleason to the famed Studebaker family, who had it moved to its present site. Since 1912, this boarding cottage, one of the few accommodations located on the lakefront with an encircling veranda, has held great appeal. Guests have enjoyed its modest rates, gracious hospitality, and, as an advertisement touted, "its abundant and excellent table board including fresh eggs, butter, chicken, vegetables, and maple syrup from farm nearby." (Courtesy of Pat King.)

The Aldine, located across from the Athenaeum Hotel, was built in 1887. Its four stories of porches and numerous windows afforded a wonderful view of the lake, as did its tower. In 1905, the guesthouse, like many other buildings, was decorated with American flags in preparation for the arrival of Pres. Theodore Roosevelt. (Courtesy of John Cofield.)

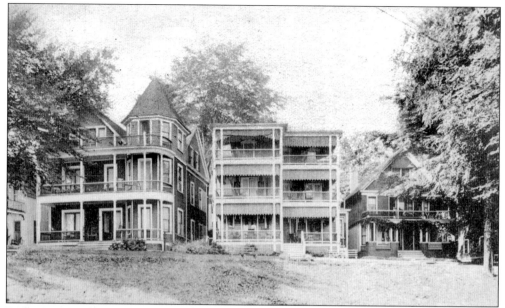

Built in 1883, the Muncie Cottages were situated close to the lake. The establishment was originally the Muncie Hotel; over the years buildings were gradually added to accommodate additional guests. The complex was finally overhauled to become the North Shore Inn. The inn succumbed to changing times and, in 1944, it was razed and replaced by condominiums. (Courtesy of Pat King.)

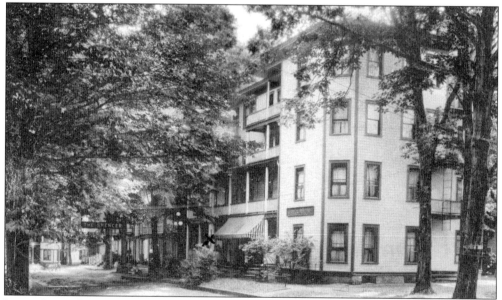

Located near the Chautauqua Amphitheater, the Spencer Hotel has been a popular year-round vacation spot since 1878. The Wheeler family, who had operated the grocery store at the Colonnade, made numerous improvements to the Spencer to accommodate lodgers. (Courtesy of Kathleen Crocker.)

The *Chautauquan* was jam-packed with advertisements for board and lodging availability. Many owners emphasized their central location with just a brief walk to the trolley depot, pier, Chautauqua Amphitheater, and the Hall of Philosophy. Modern conveniences such as lights, furnace heat, verandas, and multiple balconies—as seen here at the Penn Cottages—were enticing features.

The three-story William Baker Hotel faced Palestine Park and the Miller Bell Tower, a prime location for this popular hostelry. Relaxing on the front lawn, guests could enjoy their privacy yet have easy access to the lake and to beautiful sunsets. (Courtesy of the *Post-Journal*, Jamestown, N.Y.)

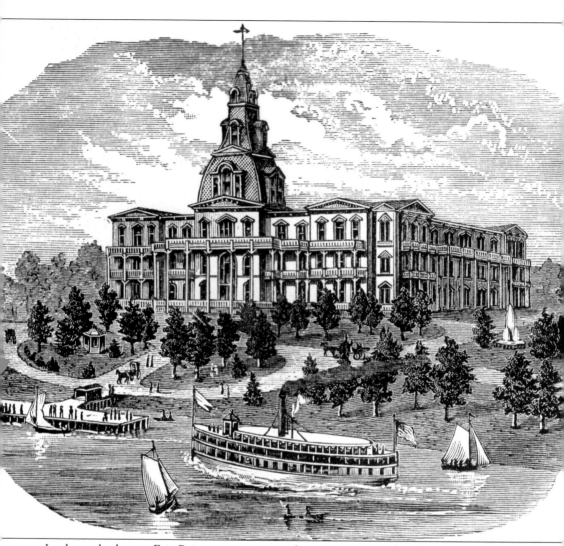

In the early days at Fair Point, some visitors chose not to camp but desired more luxurious accommodations. The Palace Hotel sufficed until the grandiose Athenaeum Hotel was opened during the 1881 season. Stockton architect William Worth Carlin was commissioned to construct the lakefront hotel. Since master Scandinavian craftsmen had settled in nearby Jamestown, sawmill workers prepared the lumber and shipped it by steamer from Jamestown to the Chautauqua grounds. According to local lore, this late-century Victorian grande dame was built by 90 men in 90 days. Because light bulb inventor Thomas Edison married the daughter of cofounder Lewis Miller, the Athenaeum Hotel was one of the first public buildings anywhere to have electric lamps.

College students from all over the country competed for staff positions at the renowned Athenaeum Hotel, revered for its gracious hospitality, elegant service, and excellent cuisine. Guests frequently reserved the same room and table assignment each year, although the $10-per-day fee on the American plan of 1883 rose each successive year. Thomas Edison, Henry Ford, and Harvey Firestone often dined at table No. 1, known as "Edison's Corner." To avoid autograph hounds, the low windows in the dining room offered the ideal escape route.

Of the many grand hotels that once lined the shore of Chautauqua Lake, only the Athenaeum Hotel retains the grandeur of bygone days; most of the others were destroyed by fire. The Athenaeum's imposing staircase, high ceilings with crystal chandeliers, magnificent parlors, expansive veranda with inviting rockers, and well-appointed rooms attract clientele from around the world. Many guests spend the entire summer at this superb lakeside resort.

Many of the present-day cottages were built on the old tent platforms and have no basements. This two-story residence on Roberts Avenue is indicative of the decorative, lacy exteriors referred to as "gingerbread." The veranda often serves as extended sleeping quarters on warm evenings, and the closeness of the houses tends to encourage neighborliness. (Courtesy of the *Post-Journal*, Jamestown, N.Y.)

Chautauquans and books seem to be inseparable. A favorite pastime is reading or napping on one's porch or veranda between concerts or lectures. Note the vase of gladiolus in the background, Chautauqua's official "porch flower." (Courtesy of the *Post-Journal*, Jamestown, N.Y.)

During the active Chautauqua summer season, from the end of June to the end of August, automobile traffic on the grounds is restricted, with few exceptions. One may drive through the gates only for business deliveries, official use, baggage handling upon arrival and departure, and for a limited number of handicapped privileges. Theatergoers are seen headed toward Norton Hall on Pratt Avenue. (Courtesy of the *Post-Journal*, Jamestown, N.Y.)

Constructed in 1928, the Brick Walk stretches from the Colonnade to the Hall of Philosophy and is a landmark for visitors. For pedestrians only, it is the main thoroughfare for wending one's way from one event to another. While en route to or from a quality performance or a stimulating lecture, it is rare not to greet or strike up a conversation with another passerby. Chautauquans know, however, that it is more rare to finish that chat, for fear that one might be late for the next scheduled program or activity. (Courtesy of the *Post-Journal*, Jamestown, N.Y.)

The Colonnade Building on Bestor Plaza has undergone many changes while housing Chautauqua's administrative offices and serving as the main business center. Before the fire of 1907, several independent enterprises there met the needs of the community. Staples such as milk, meat, bread, fruits, and vegetables could be purchased, and correspondence could be received and sent at the post office that was located in this complex at one time. Badly damaged in the January 1961 fire, the Chautauqua print shop was fortunate to find a temporary location in Jamestown. (Courtesy of Jane Currie.)

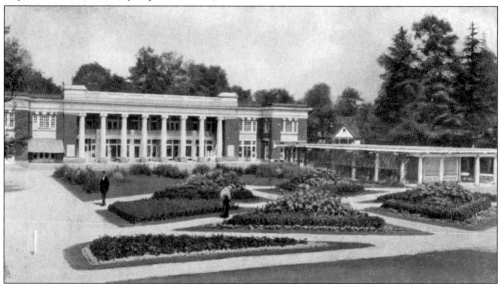

This similar view of the Colonnade clearly shows the manicured landscape of what later became known as Bestor Plaza, with crisscross walkways. At the extreme right is the Pergola, a vine-covered refreshment stand with some merchant stands, designed by Buffalo architect Edward B. Green. It was in operation from 1906 until its removal 40 years later. (Courtesy of Kathleen Crocker.)

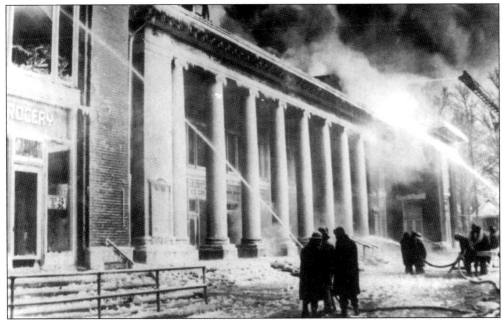

This is a familiar scene to many Chautauquans who have vivid recollections of the devastating Colonnade fire of January 1961. The fire started in the third-floor quarters, which afterward were never replaced. The prompt action of dozens of local volunteer firefighters and many from surrounding communities was credited with saving all but one life. (Courtesy of the Samuel M. Hazlett family.)

The Colonnade facility has drawn numerous residents to its location, as indicated by the number of bicycles seen above. Although the administrative offices were temporarily transferred to Smith Memorial Library following the 1961 fire, Buffalo architect Edward B. Green's hasty rebuilding effort allowed the staff to return to the Colonnade within a surprisingly short period of time so that standard operating procedures could resume. (Courtesy of the *Post-Journal*, Jamestown, N.Y.)

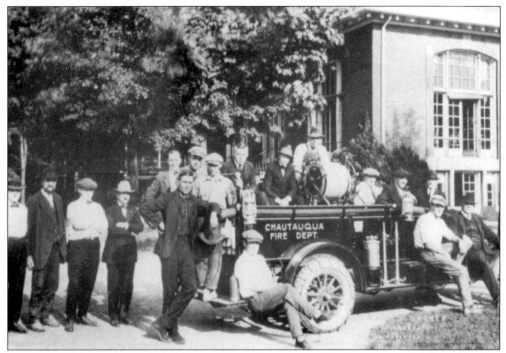

In 1907, the Chautauqua Fire Company's volunteer membership was composed of many influential community members. Because of the closeness of the wooden structures, all-night duty was drawn in case of emergencies. During the summer, the fire crew served on standby near the Chautauqua Amphitheater during the crowded Sunday morning worship service. The fire hall, in the early days, was known as a lively gathering place. (Courtesy of the Samuel M. Hazlett family.)

Civil War veteran Capt. Philander W. Bemis is often caricatured speeding on his bicycle throughout the grounds, with his long beard flying in the wind. He was the head of the Chautauqua Police Force and a symbol of safety and security to the young and the old. (Courtesy of the Samuel M. Hazlett family.)

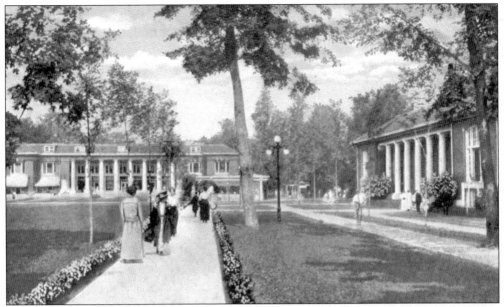

When the name Fair Point was officially changed to Chautauqua on February 24, 1879, the post office opened its doors. Like other facilities, it was moved numerous times. When at the rear of the old Palace Hotel, customers queued up outdoors. But regardless of its locale, in the Colonnade or the Chautauqua Traction office building or in the old museum, Chautauquans have been privileged to have its services handy. The post office is located on the right side of this view, which illustrates its relation to the Colonnade and to the Pergola. (Courtesy of Kathleen Crocker.)

The red brick post office, another Chautauqua building designed by Buffalo architect Edward B. Green, has remained on Bestor Plaza since 1909. It is one of the few buildings that serves the community year-round. In the winter months, only a few hundred citizens have private boxes there. For nine weeks each summer, the courteous and efficient staff must make huge adjustments to accommodate the thousands who rely upon its services. A printing press and bindery in the lower level were replaced by the Chautauqua Bookstore, which features works of visiting lecturers and performers. (Courtesy of the *Post-Journal* Jamestown, N.Y.)

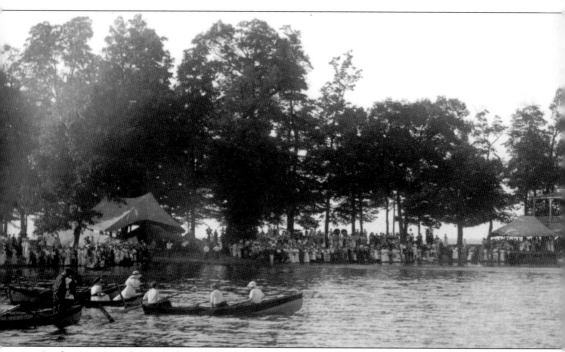

In the summer of 1914, pilot Alfred J. Engel made airmail history. He was assigned the official mail route over Chautauqua Lake, shuttling the delivery of postcards back and forth between Celoron, Lakewood, Bemus Point, Chautauqua, and Mayville. His experimental Chautauqua Lake Route No. 607004 was one of nearly 100 routes in existence between 1910 and 1916. At

Alfred J. Engel piloted a single-pontoon Curtiss Hydro aero-plane named the Bumblebee. His unique airmail service lasted only for the summer of 1914; however, he was credited with piloting the first regular airmail route in the United States. During some deliveries he was reputed to have circled low over the lake steamers, thrilling crowds of spectators. (Courtesy of Devon Taylor.)

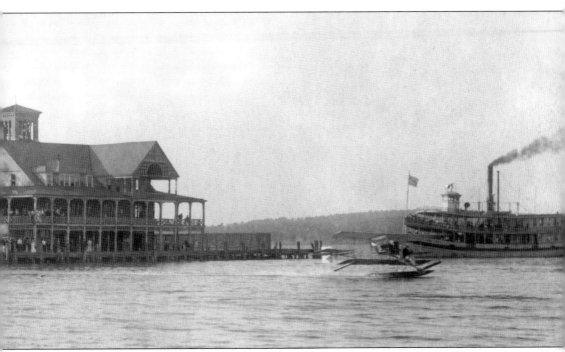

that early date, the postcards were labeled "aerial mail" since there were no airmail stamps yet. After that summer, deliveries were once again assigned to horse-and-buggy rural routes. It was another 29 years before Jamestown had bona fide airmail service. (Courtesy of Jane Currie.)

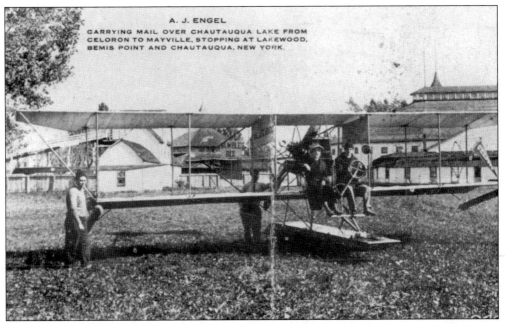

A. J. ENGEL
CARRYING MAIL OVER CHAUTAUQUA LAKE FROM CELORON TO MAYVILLE, STOPPING AT LAKEWOOD, BEMIS POINT AND CHAUTAUQUA, NEW YORK.

In 1913, pilot Alfred J. Engel was hired as a main attraction at the Celoron Amusement Park, seen in the background. A poster advertised his performance: "Two Flights Daily by Aviator Engel . . . 100 miles an hour in the air and 45 miles an hour on the water. Fare including admission to Assembly grounds 75 cents via Chautauqua Steamboat Co." (Courtesy of Devon Taylor.)

Bestor Memorial Plaza was dedicated to Arthur E. Bestor, president of Chautauqua, for his enormous contribution to the institution and in honor of his 40 years of service. The central quadrangle is bordered by brick walks fronting the Colonnade, the post office and bookstore complex, Smith Memorial Library, and the St. Elmo Hotel. Bestor Plaza is an ever-active adult meeting place, a peaceful rest stop under the shade trees, and a spot for children to frolic. Its center fountain bears four inscriptions, one on each face of the concrete shaft, reflecting the institution's major emphases: religion, knowledge, art, and music. (Courtesy of the *Post-Journal*, Jamestown, N.Y.)

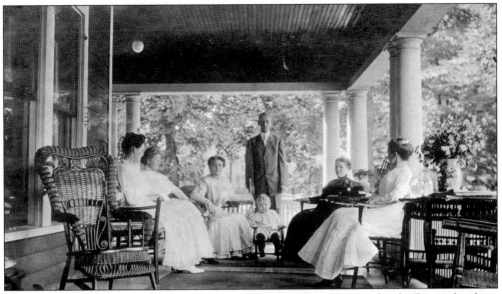

This typical Chautauqua porch party was hosted at One Root Avenue by the Bestor family in 1909. Arthur E. Bestor is standing in the center with his son Arthur Jr. in front of him, and his wife, Jeanette, is in the dark dress on the right. Note the wicker furniture on the spacious porch, which was later enclosed. (Courtesy of Mary Frances Bestor Cram.)

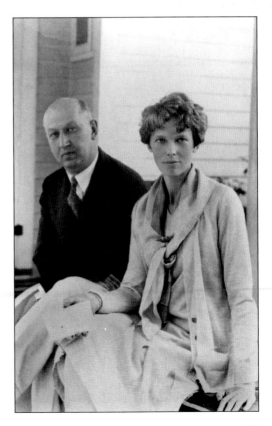

When aviator Amelia Earhart attended a luncheon in her honor at the home of Arthur E. Bestor, people assembled outside, seeking a glimpse of "America's latest star," Bestor's daughter Mary Frances recalls. In the afternoon lecture at the Chautauqua Amphitheater, Earhart spoke to an audience of 5,000 people, eager to learn of her record-breaking transatlantic flight the previous month. She detailed her 20 hours and 40 minutes spent aboard the trimotored Fokker *Friendship*.

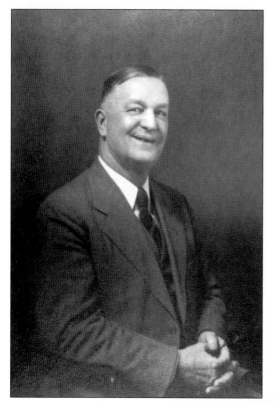

Chautauquans are indebted to Samuel M. Hazlett, whose business acumen, organizational skills, time, and energy played a major role in stabilizing the institution's finances following the Depression. Hazlett succeeded Arthur E. Bestor as president and served the community with determination and faith. His outstanding leadership guided Chautauqua through the darkest period of its history. (Courtesy of the Samuel M. Hazlett family.)

Shown at right is the collecting of the community gift at Old First Night, the annual commemoration of the Opening Day at the first Chautauqua Assembly on August 4, 1874. The remembrance is a symbolic link between the early and present Chautauqua and a reaffirmation of its validity. It is a time of sentiment, devotion, and family gathering at the Chautauqua Amphitheater. Since 1907, individuals and organizations have pledged financial assistance by bringing monetary birthday gifts that augment income from gate receipts and helped finance renovations of facilities such as the Pier Building and the Chautauqua Golf Course. (Courtesy of the Samuel M. Hazlett family.)

Since 1929, members of the Chautauqua Women's Club have entertained distinguished guests and hosted quality programs in this spacious clubhouse. The organization addressed important topics and served as a source of inspiration for Chautauqua women as far back as the Gilded Age. According to Mary Lee Talbot, granddaughter of Samuel M. Hazlett, membership in women's clubs "quickened their minds, fostered a sense of independent achievement, and lessened women's isolation." (Courtesy of Jane Currie.)

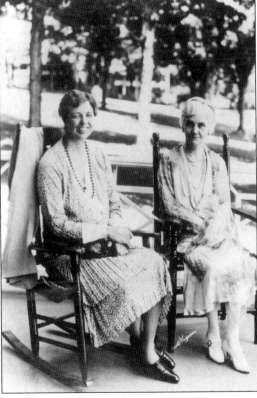

Seated on the porch of the Women's Club are Eleanor Roosevelt, left, and Anna Pennybacker, the former president of the General Federation of Women's Clubs and the first female Chautauqua trustee. Remembered as an eloquent crusader, Anna Pennybacker brought many famous women to the Chautauqua platform. In 1929, she gave Franklin D. Roosevelt the honor of bestowing the coveted Women's Club lifetime membership on his wife, Eleanor Roosevelt, at a reception following one of his addresses.

More than 900 people, including members of the Chautauqua Women's Club, were photographed in the East Room of the White House with Eleanor Roosevelt, front left, and Arthur and Jeanette Bestor, front center. Following the luncheon, the Women's Club contingent was entertained at the national headquarters of the General Federation of Women's Clubs in Washington, D.C. Anna Pennybacker helped establish a link between the Chautauqua Literary and Scientific Circle and women's organizations throughout the nation. These organizations focused their attention on a variety of social causes, and their members sought to better their own homes and communities and, in turn, the world. (Courtesy of the Samuel M. Hazlett family.)

Mrs. Roosevelt

requests the pleasure of the company of

Mrs. Jacobs

at a buffet luncheon

Monday, January the twenty-first

at one o'clock

On January 21, 1935, members of the Chautauqua Women's Club received these personal invitations from Eleanor Roosevelt to attend a luncheon at the White House. Eleanor Roosevelt first visited Chautauqua in 1927, when she lectured at the Women's Club discussing the "Civic Responsibilities of Women." Her other visits were as the wife of the assistant secretary of the navy, as the wife of the governor of New York State, and, finally, as the wife of the president of the United States. (Courtesy of the Samuel M. Hazlett family.)

Many famous women have graced the prestigious Chautauqua Women's Club through the years. Seated, from left to right, are Mrs. Thomas Edison, Mrs. Henry Ford, Mary Miller Nichols, Anne Studebaker Carlisle, and Mrs. Robert A. Miller; Anna Pennybacker stands behind them. These public figures were wives and mothers who maintained their homes and also assumed leadership roles in their communities. They were respected for their social, educational, and cultural contributions to Chautauqua and to their hometowns.

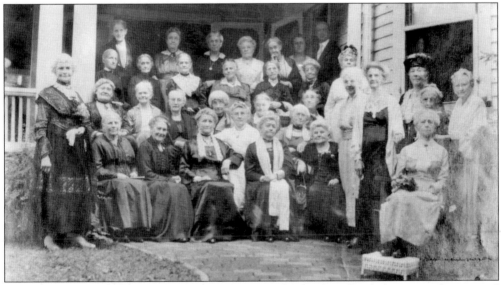

Beginning in the summer of 1920, Jeanette Bestor, Chautauqua's first lady, initiated an annual tea in her home to honor the Golden Belles, members of the Women's Club over the age of 75. This 1922 photograph includes Martha Godard Barrett, seated in the second row third from the left, a member of the Chautauqua Literary and Scientific Circle Class of 1882 and the great-grandmother of coauthor Kathleen Crocker.

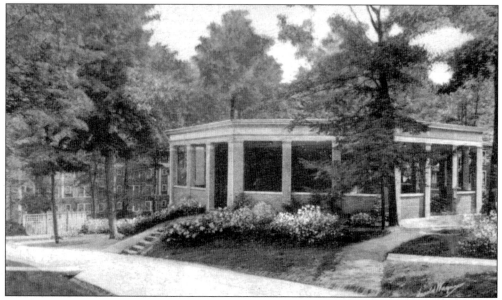

Smith Wilkes Hall, built in 1924, was one of two buildings donated by patron Mrs. A.M. Smith Wilkes. In addition to being used as a lecture hall, it has served as the headquarters of the Bird, Tree and Garden Club, whose original purpose was the protection of Chautauqua's natural beauty. Its mission was expanded not only to promote bird, tree, and wildflower conservation but also to preserve and beautify the entire Chautauqua grounds and to encourage the cultivation of private gardens. Mrs. Thomas Edison, an ornithologist, was one of its presidents. (Courtesy of Kathleen Crocker.)

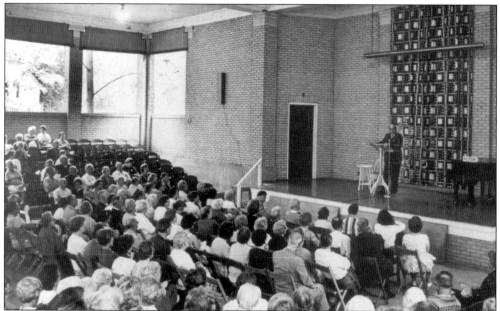

Built into the hillside in the Greek tradition, Smith Wilkes Hall, the yellow brick open-air theater, seats 450 and has 14 large window openings. Karl Menninger, the noted American psychiatrist, often spoke here, discussing the latest developments in psychiatry and the field of mental health. His family also enjoyed their Chautauqua visits.

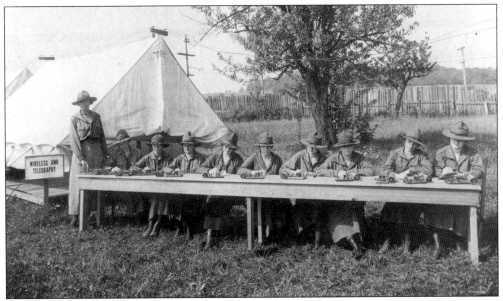

Mrs. George E. Vincent, daughter-in-law of the cofounder, was the commandant of the National Service Schools at Chautauqua during World War I. The school for young women was created to teach the essential skills of telegraphy and wireless, among others. The military training camp tents were located on the Overlook, a large area at the south end of the grounds.

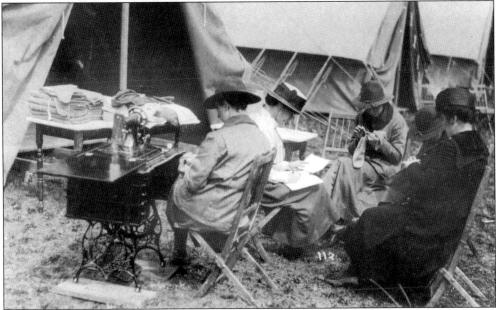

Mary Frances Bestor Cram, daughter of Arthur E. Bestor, vividly recalls women's roles in the war effort, especially her own mother's involvement. Women of all ages learned to roll bandages from torn sheets for use as surgical dressings. Sewing was done by machine and by hand. Free wool was provided so that large black shawls could be crocheted for servicemen in France and Belgium. It was during the war years that knitting became a common practice during Chautauqua Amphitheater and Hall of Philosophy lectures, a practice that continues to this day.

Chautauqua has taken enormous pride in its education, religion, and recreational center, serving all age groups with unlimited choices and opportunities for self-improvement. (Courtesy of the *Post-Journal*, Jamestown, N.Y.)

Five

THE PLATFORM AND PERFORMING ARTS

The Chautauqua Movement promoted intelligence and culture, embracing cofounder John Heyl Vincent's original concept of Chautauqua: "All Things of Life . . . Art, Science, Society, Religion, Patriotism, Education . . . whatever tends to enlarge and ennoble." Cofounder Lewis Miller also wanted Chautauqua visitors to return home to "weave into the fiber of the homework the newly gathered inspirations and strengths."

Thus, the broadening of Chautauqua's general programming was inevitable. By 1900, educators and ministers were joined on the Chautauqua platform by politicians, authors, and reformers as well as credible, qualified, and respected thought provokers from every phase of society. Lectures on every conceivable topic were designed to inform and stimulate audiences. The essence of the Chautauqua Movement remains as a national forum for the open discussion of ideas and issues; a spirit of democracy and a lack of censure are its hallmarks. Although often mimicked, Mother Chautauqua's lecture platform is unequaled.

Following World War II, under the leadership of Arthur E. Bestor, Chautauqua became internationally renowned for the caliber of its presentations and presenters and for its performances and performers. Both played a huge role in the overall picture. No longer a mere adjunct, the arts in the form of ballets, operas, stage productions, popular entertainers, and recitals became an integral part of Chautauqua. Concerts and exhibits satisfied every palate. Ralph H. Norton, a former trustee, accurately stated that Chautauqua provides "a veritable feast for the music lover."

The School of Music first concentrated on piano, voice, organ, and instrumental instruction and enrichment. Following the installation of the Massey Organ, the renovated Chautauqua Amphitheater, with its increased seating capacity, made it the center for most musical programs. Celebrity guest soloists, organ recitals, pop concerts, and choral events filled the season's calendar.

Having its own symphony orchestra, opera company, band, and choirs made Chautauqua truly unique; amazingly, quality performances resulted from summer associations only. The

outstanding talent of such individuals as Albert Stoessel, Alfredo Valenti, Evan Evans, and Franco Autori proved invaluable to the success of the music programming. Collaboration with the Juilliard School of Music led to a scholarship program for students of piano, voice, and violin. Unfortunately, this connection ceased with the deaths of Ernest Hutcheson, Stoessel, and Valenti.

By the 1940s, the comprehensive music program's calendar listed more than 30 orchestral concerts, a five-opera series, choral and organ and chamber music concerts, faculty and student recitals, and lectures on musical topics. Local and national broadcasts of Chautauqua's music programs have impacted its reputation since the 1950s.

Theater study began in the late 19th century at Chautauqua. Morality plays and dramas sponsored by the Chautauqua Literary and Scientific Circle were among the early performances. In addition to the 50-year residence of the Cleveland Playhouse, other theater groups on the grounds have included the Lake Erie Repertory Company, the Chautauqua Conservatory Theater, and the Jamestown Players, which featured Jamestown native Lucille Ball in the 1930 performance of *Within the Law*. Norton Hall, home to the Chautauqua Opera Company, also housed musical and dramatic performances until it shared the facility with the School of Drama.

In addition to the Juilliard students, other performing students also benefited greatly from their study at Chautauqua. Members of the student symphony worked with master musicians in daily courses and were privileged to attend their mentors' performances at evening concerts. Theater school students were trained to act and also to perfect their skills in makeup, stagecraft, and directing, and the opera company's apprentice program showcased budding talent.

Mr. and Mrs. Thomas Edison and Henry Ford attended *Martha*, by Friedrich Flowtow, Chautauqua's first opera on July 19, 1929. The above stage-door photograph is from *Pagliacci*, performed on the same stage at Norton Hall the following year. (Courtesy of Nellis DeLay Harvuot.)

Frances Willard was a graduate of Northwestern Female College. At the age of 32, she became president of Evanston College for Ladies, which merged with Northwestern University. She left the academic life to enroll in the temperance army, and under her leadership, the Women's Christian Temperance Union enlisted thousands of women. It was the first women's organization to draw membership from all levels of society. It expanded its emphasis to encompass issues of women's suffrage, kindergartens, social purity, and child labor laws. Although it was a Christian organization, Jews, Catholics, and Protestants worked together to redeem America. Willard considered herself "a charter member of Chautauqua."

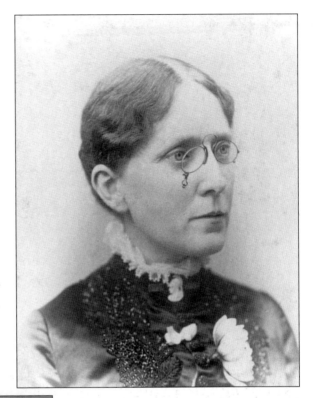

Carrie Chapman Catt, founder of the National League of Women Voters, first visited Chautauqua in 1900. Successor to Susan B. Anthony as president of the National American Suffrage Association, she joined Anthony and Anna Howard Shaw during Women's Week in 1918 to address the topic "For What Are We Fighting?" Speaking to the Chautauqua Women's Club, she urged passage of the Nineteenth Amendment, admonishing the audience that "You may be working in the Red Cross and knitting socks and sweaters, but . . . you are not doing your part if you fail to do all in your power to support and defend this great issue."

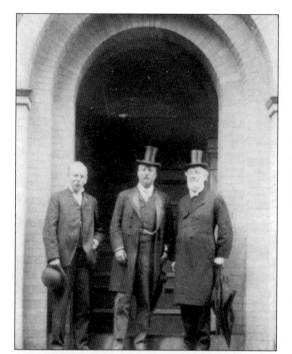

Pictured, from left to right, on the steps of Higgins Hall are Jacob Riis, Pres. Theodore Roosevelt, and cofounder John Heyl Vincent, following a formal breakfast in honor of the president. A visitor to Chautauqua on several previous occasions, Roosevelt arrived on August 11, 1905, to lecture on his initiation of the Roosevelt corollary to the Monroe Doctrine. It was the first time an American president had chosen Chautauqua as the site for an important policy speech.

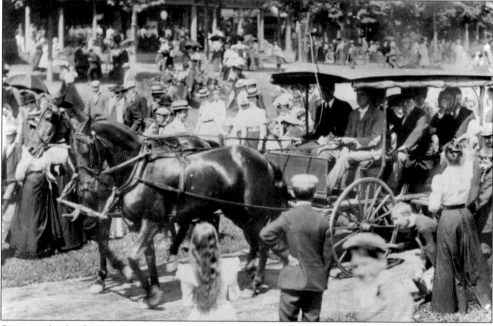

Seen in the back seat to the right, tipping his hat to the crowd, is Theodore Roosevelt, who made repeat visits to Chautauqua. In 1894, as U.S. Civil Service commissioner, he spent nearly a week at the Athenaeum Hotel. He and his wife returned five years later when he became governor of New York. In 1905, he arrived on a special car of the Chautauqua Traction line at the patriotically decorated grounds and gave his final speech in favor of women's suffrage. His familiarity with the grounds resulted in his pronouncement that a Chautauqua audience "is typical of America at its best."

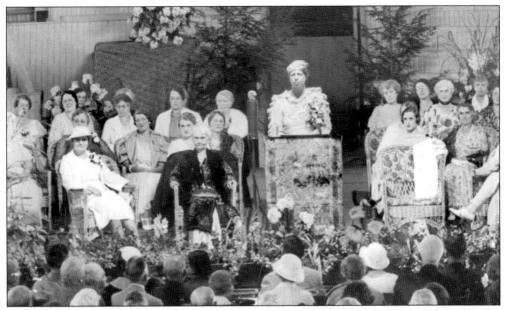

Eleanor Roosevelt typified Chautauqua women and felt very much at home on the grounds. She dined often at the Bestor residence and spoke frequently at the Women's Club and on the Chautauqua Amphitheater stage, as seen above. A role model for women everywhere, she suggested when questioned during an interview that women could best help in the postwar period "just by being intelligent." Officers of the Women's Club are seated in the front row on stage; note the women's hats and the wicker furniture.

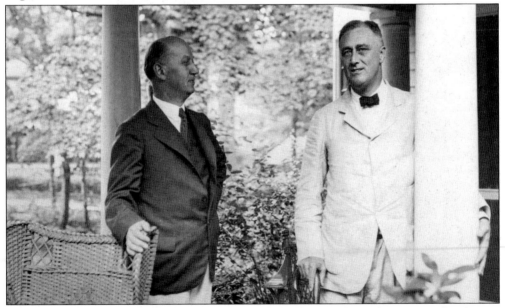

Franklin Delano Roosevelt was photographed on the Bestor family porch in 1929, when he was governor of New York. During his fourth visit, on August 14, 1936, Roosevelt used the Chautauqua lecture platform to deliver one of his most powerful speeches as president. His famous "I Hate War" message, was heard by an overflowing Chautauqua Amphitheater audience. This was the president's last appearance in Chautauqua County.

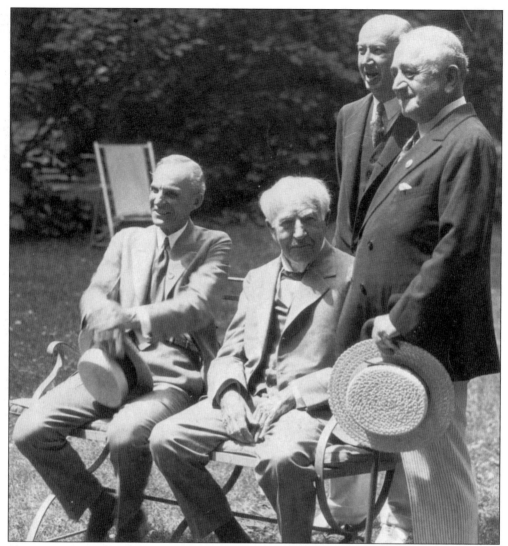

Captured in this photograph are four famous men of their time. Seated, from left to right, are Henry Ford and Thomas Edison; standing, from left to right, are Arthur E. Bestor and Adolph Ochs, publisher of the *New York Times*. They were at Chautauqua in 1929, along with 2,000 other visitors, to attend the Lewis Miller Centenary. During their stay, they toured the grounds and, prior to their interview with the press and photographers in the Miller Cottage garden, Edison and Ford were entertained at a children's reception. Edison, the "Wizard of Menlo Park," had married Lewis Miller's daughter Mina in 1886, and the couple were active Chautauquans. In fact, Edison was the honoree of the Chautauqua Literary and Scientific Circle Class of 1930, and Mina Edison, following her husband's death, accepted his diploma. Henry Ford's relationship with the Miller family began when he was the Michigan sales representative for Miller's invention, the Buckeye mower and reaper. To celebrate the 100th anniversary of the birth of Miller, Chautauqua held a Festival of Light, commemorating Edison's invention of the incandescent light bulb. Special bulbs lighted the pathway from the Amphitheater down to Miller Park, encircling that area, and the Miller Bell Tower was lighted on all sides with floodlights at its base. The lights were visible for miles up and down the lake. (Courtesy of Alan E. Nelson.)

The Miller Cottage, the summer residence of cofounder Lewis Miller, was built in 1875 and is an early example of prefabricated housing. The pieces were numbered and assembled in his hometown of Akron, Ohio, and were then shipped to Chautauqua. Although not the most impressive or grandest home on the grounds, it was designated as a National Historic Landmark in 1969, signifying its importance as the preserved dwelling of the famous educator and inventor. The rustic two-story home overlooked the original amphitheater and was located in the heart of the camp meeting grounds, which became Miller Park. The wooden building, with its crisscross exterior providing the structural support, originally used the adjacent tent as a male dormitory and the home's second floor for women. In 1922, Mina Miller Edison, the cofounder's daughter and a Chautauqua trustee, redesigned the cottage to encourage public visitation. It is currently owned by Nancy Miller Arnn, Miller's granddaughter and goddaughter of Mina Edison. After the death of her parents, Nancy Miller made her home with the Edisons at Glenmount. (Courtesy of the *Post-Journal*, Jamestown, N.Y.)

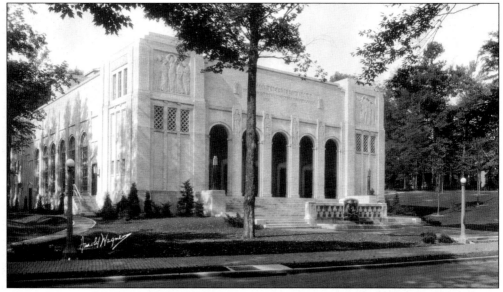

Norton Memorial Hall was built in 1929 to house the theater and opera companies. Increasing scheduling conflicts forced musical performances once given in the Chautauqua Amphitheater to be moved to Norton Hall. Given by Mrs. Oliver W. Norton as a memorial to her husband and daughter Ruth, it is a fine example of an individual Chautauquan's generosity. The family stipulated that operas be performed in English, that American singers be encouraged to develop their talent, and that staging be integral to each presentation. (Courtesy of Alan E. Nelson.)

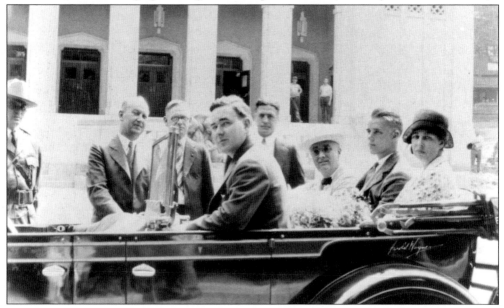

In 1929, Gov. Franklin D. Roosevelt visited the newly constructed Norton Hall. En route to the Chautauqua Amphitheater are, from left to right, Arthur E. Bestor, Chautauqua Institution president; Ralph Norton, son of Mrs. Oliver W. Norton, the donor of the new hall; and Guernsey T. Cross, the governor's secretary. Seated, from left to right, are Roosevelt, his son Elliot, and his wife, Eleanor. Although Eleanor Roosevelt came to Chautauqua frequently, this was the only time that she accompanied her husband to the grounds.

Russian-born Mischa Mischakoff first appeared on the Chautauqua stage in 1926 as its concertmaster and, three years later, he performed at the dedication of Norton Hall, along with Albert Stoessel. The Mischakoff String Quartet laid the foundation for the Chamber Music Society, which gave frequent recitals in Smith Wilkes Hall and at the home of Mrs. Ralph H. Norton, one of the most generous patrons of the Chautauqua arts. From left to right are Mischakoff, Reber Johnson, Georges Miguelle, and Nate Gordon.

Before coming to the United States, Mischakoff had been concertmaster in both Moscow and Warsaw. Conductor Walter Damrosch invited the exceptional violinist to join his New York Symphony Orchestra, and the Juilliard School of Music also welcomed him to their faculty. Several of Chautauqua's music elite pose with Mischakoff in 1934 at Norton Hall. Seated, from left to right, are Harrison Potter, unidentified, Caroline George, Mischa Mischakoff, and Mrs. R.H. Norton. Standing, from left to right, are Julius Huehn, Georges Miguelle, unidentified, Albert Stoessel, Arnold Schönberg, Reber Johnson, and George Barriere. (Courtesy of Nellis DeLay Harvuot.)

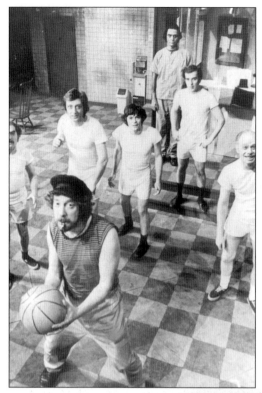

The opening of Norton Hall in 1929 gave the Chautauqua Repertory Theater a suitable home. The latter was replaced by the Cleveland Playhouse actors, who spent 50 summers at Chautauqua, beginning in 1930, performing Broadway productions and revivals of a variety of plays. This particular photograph is from their production of *One Flew over the Cuckoo's Nest*, a provocative work presented in 1973 to a standing-room-only crowd.

Another memorable stage performance that delighted the audience was that of Jose Greco, who danced in concert with the Chautauqua Symphony and dance school students. Also a favorite was the Robert Joffrey Ballet Theater troupe, which was featured in Chautauqua Opera Association productions. In 1959, this group of versatile young dancers assembled by Joffrey, visited Chautauqua before leaving on a national tour. (Courtesy of the *Post-Journal*, Jamestown, N.Y.)

Lt. Cmdr. John Philip Sousa's band was often scheduled to entertain for the final Chautauqua Golf Course banquet. This photograph of John Philip Sousa, seated in the center with Arthur E. Bestor on the left, was taken in 1931 during his last Chautauqua visit. Sousa was the well-known director of the U.S. Marine Band from 1880 to 1892. Known as the "March King," he composed comic operas, but his signature work was "Stars and Stripes Forever."

Al Hirt, famed trumpet virtuoso, performed several times during the 1960s and 1970s on the Chautauqua Amphitheater stage. He was just one of thousands of Chautauqua's Who's Who of popular artists throughout the years, joining the company of Victor Herbert, Meredith Wilson, Duke Ellington, Count Basie, the Mormon Tabernacle Choir, the Kingston Trio, the George Shearing Quintet, ad infinitum.

Visitors to Chautauqua seldom forget the unique village of practice shacks situated near the Main Gate. Erected in the early 1900s, each of the 32 cabins was utilized by musicians for their rehearsals. The melodious sounds of not only pianos but also strings, woodwinds, brass, and voice emanated throughout the grounds. Named for famous composers, the most notable of these is probably the Gershwin cabin where, in 1925, George Gershwin composed his famous Concerto in F.

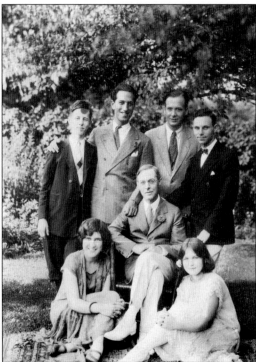

Pictured are George Gershwin and some of the other musicians who performed on the Chautauqua stage in the late 1920s. Seated in the center foreground is Ernest Hutcheson, dean of the Juilliard School of Music's graduate program and head of the music department at Chautauqua. Standing, from left to right, are an unidentified man, Gershwin, Oscar Wagner, and another unidentified man. The women were most likely piano students of Hutcheson. (Courtesy of Bob Williams.)

Between 1953 and 1972, the famous concert pianist Van Cliburn appeared on the Chautauqua Amphitheater stage as both guest conductor and soloist. He is pictured here during his 1953 recital, five years before winning the coveted Russian Tchaikovsky Piano Competition at the Bolshoi Theater in Moscow.

Born in St. Louis in 1894, Albert Stoessel dominated Chautauqua's music department from 1921 until his sudden death in 1943. His exceptional talents as a composer, conductor, violinist, and music instructor led to unprecedented responsibilities in Chautauqua's music program. He was director of the New York University Music Department, conductor of the Chautauqua Symphony Orchestra, director of Chautauqua's Music Department, and founder of Chautauqua's opera company—all at one time. (Courtesy of Nellis DeLay Harvuot.)

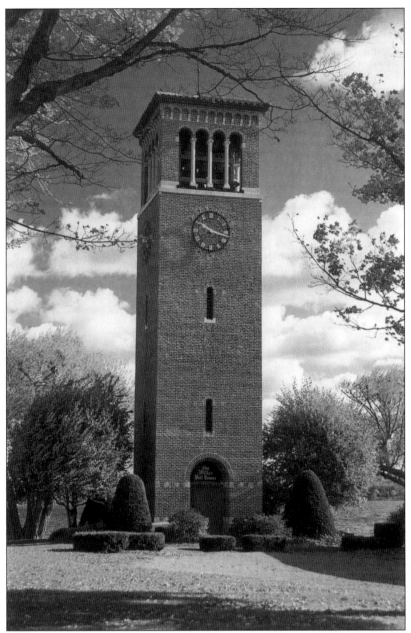

At the dedication ceremony of the Miller Bell Tower, on August 2, 1911, John Heyl Vincent paid tribute to its namesake: "Surely Chautauqua owes a debt of gratitude to Lewis Miller for it was he who proposed going into the woods with the Chautauqua Idea, and the Bell Tower, which marks the 'Point,' is properly named for him. The tower is now the most distinctive shore mark on the Lake." (Courtesy of Jane Currie.)

Six

CENTENNIAL

In 1924, in celebration of the golden anniversary of Chautauqua, many congratulatory messages were sent, including one from Pres. Calvin Coolidge to Arthur E. Bestor, the institution's president. The essence of that message was "the earnest hope that Chautauqua may go on and on, serving the cause of culture, education, and liberalism as it has done from the beginning." It concluded with Coolidge's "sincere wishes for the future of the Institution."

In the same spirit of optimism, despite the threat of its extinction during the Depression years, the Chautauqua community celebrated its centennial 50 years later, in 1974. An extremely ambitious and dedicated committee initiated plans years in advance. Their organization and effort brought to the institution they loved a sense of pride, accomplishment, and confidence in its future. To honor the past, their stated purpose was threefold: first, to recognize the institution's historic aspect; second, to acknowledge the founders' efforts and the resulting programs in education, religion, and the arts; and, third, to highlight Chautauqua's contributions to American culture.

Despite the scope of their undertaking, the Centennial Committee was successful in its endeavors. The institution was recognized and given membership in the National Register of Historic Places, and a commemorative stamp was issued by the U.S. Postal Service; both of these noteworthy honors were tremendous coups for the committee members.

Before refocusing the nation's attention on Chautauqua, many additions and improvements were necessary. Some of the birthday "gifts" included the Carnahan-Jackson Memorial Garden, the Lincoln Dormitory, and the Sample Memorial Playground donated by family members. Among the renovated buildings were the Hall of Christ, the Hall of Philosophy, and the Miller Bell Tower.

Other eye-catching commemoratives were the specially designed centennial flags flown at the Main Gate, at the Chautauqua Amphitheater, and at the residence of the president, Oscar Remick. In addition, an enormous floral sign spelling out "Centennial 1874–1974" spread across the front lawn of the Athenaeum Hotel.

To christen the 1974 season, a spectacular three-day open regatta was sponsored by the Chautauqua Yacht Club. Throughout the summer season, a vast array of exhibits was located throughout the grounds, with a companion guide for visitor use. Perhaps the most extensive display was at Smith Memorial Library, where memorabilia, photographs, and objects depicting the hundred years' history were on loan from Chautauqua families.

Departments, too, chose to pay homage to Chautauqua. Large audiences were drawn to the morning lecture series "The Coming of Age: A Celebration." The Chautauqua Opera Association produced its tribute: the world premiere of an American opera set during the post–Civil War era, the period of Chautauqua's founding. The Chautauqua Literary and Scientific Circle Class of 1974 pledged commitment to each member's dream to help shape the future as indicated by its motto "Faith in the Future."

The centennial year was one of fiscal stability, high morale, fierce loyalty, and pride. No doubt, cofounders Lewis Miller and John Heyl Vincent would have been delighted with Arthur E. Bestor's assessment back at the 50-year celebration in 1924, when he stated that Chautauqua "has been a center for patriotic pride, an experiment station for new educational ideas and a national influence making for intelligence, religious tolerance, and democracy."

Building on the past, the Chautauqua Idea evolved into a dynamic force in contemporary America. Ever the pioneer, Chautauqua became a powerful cultural force with wide scope and influence, extending far beyond the original 50-acre tract at Fair Point.

The centennial celebrations honored the accomplishments of all Chautauquans who had helped to perpetuate the vision of Lewis Miller and John Heyl Vincent. After 1974, individual responsibility would determine its course. Past performance and a progressive spirit, however, indicated that George E. Vincent, the cofounder's son, who also gave years of service to the institution, was correct in acknowledging that "Chautauqua's greatest service is in its future rather than in its past." The outward signs of affection during its 100th birthday were symbolic of the deep love of Chautauquans for their home; united and optimistic, they made a genuine commitment to future generations.

Oscar Remick, Chautauqua's president, receives the commemorative stamp album from F.X. Biglin. This second stamp in the Rural America series was issued by the U.S. Postal Service on August 6, 1974, during the formal observance of the 100th anniversary of the founding of the Chautauqua Institution. It is estimated that nearly one million envelopes bearing the stamp were canceled at the local post office that day for delivery to stamp collectors worldwide.

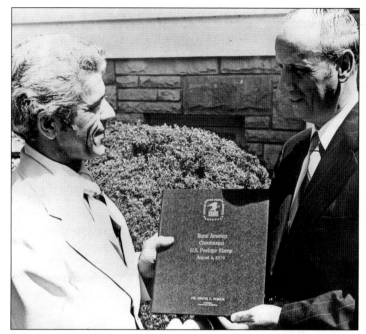

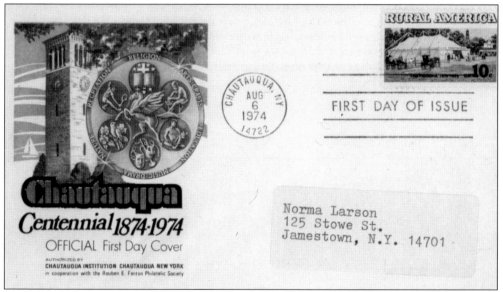

The design on the 10-cent stamp features a tent with a sign "Chautauqua" over its entrance. In the foreground are parked horses and carriages, and people are seen entering the tent for a performance. "Rural America" appears in blue capital letters across the top. Across the bottom in black lettering is "Chautauqua 1874–1974" and "US 10c." The stamp was designed by John Falter of Philadelphia who, as a boy, remembered that "Chautauqua" came to his hometown of Falls City, Nebraska, and that he attended with his mother. Thus, part of his own home and the nearby water tower are in the background. This first day cover was sent to Norma Larson who today, at age 98, still remembers the excitement of that special event. (Courtesy of Sydney S. Baker.)

The Carnahan-Jackson Memorial Garden near the Chautauqua Amphitheater and the Presbyterian House was an example of Chautauqua's determination to improve the appearance of the grounds in advance of its 100th birthday celebration. Other public and private gardens, hanging baskets, and improved landscaping received great attention, especially during the Bird, Tree and Garden Club's centennial house tour. At that time, the service organization awarded blue ribbons for unique features, plantings, and overall image.

The dedication of the Lincoln Dormitory, a gift of Mrs. John C. Lincoln in memory of her husband, was another observance and sign of generosity in anticipation of the centennial. The long-needed spacious and functional building housed young women enrolled in the Chautauqua Summer Schools programs.

In 1973, prior to the centennial, Welch Foods renewed its relationship with Chautauqua by opening Welch's Refreshment Pavilion beside the post office on Bestor Plaza. Shown at the ribbon-cutting ceremony are, from left to right, R. Craig Campbell, president of Welch Foods of Westfield, New York, and Oscar Remick, president of Chautauqua. Located in the heart of the greater Chautauqua and Erie grape belt, Welch's Grape Juice Company predated Chautauqua. The enthusiasm of Charles E. Welch, company president, for Chautauqua spurred his service as a trustee of the institution from 1909 until his death in 1926.

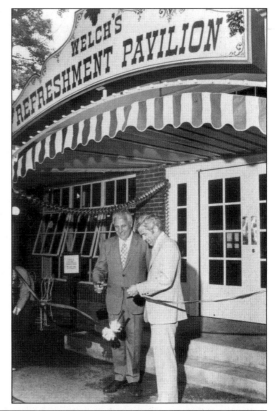

The early atmosphere of Welch's Pavilion mirrored the Victorian atmosphere that permeated the entire Chautauqua community during the summer of 1974. These hostesses served Welch beverages to the many visitors who frequented their establishment, which was remodeled as a 1920s-style old-fashioned ice-cream parlor and gazebo. The marbleized tabletops, wire-backed parlor chairs, heavy wooden booths, and bright-colored awnings were an inviting place to relax and people watch. (Courtesy of the *Post-Journal*, Jamestown, N.Y.)

The Centennial Committee hired band director Skitch Henderson to conduct an afternoon concert of the Chautauqua Symphony Orchestra prior to the Old First Night party of 1974, and the Peter Duchin Orchestra was the committee's choice of entertainment for the Centennial Ball. Committee members worked diligently and confidently to produce a variety of appealing events and, in the process, attracted additional people to assume a more active role in the Chautauqua community.

Held in the Athenaeum Hotel ballroom, the Centennial Ball was the culmination of the festivities. Enthusiastic merrymaking that evening in particular exuded the joy and pride of every resident. Couples crowded the dance floor in step with waltzes, fox trots, sambas, and the Charleston. When the musicians hired for the younger set failed to appear, children and grandchildren were invited to join the adults, although some feared that the hotel floor would cave in with the undue weight. Fortunately nothing marred that treasured night of nights. The Grand March was led by Oscar Remick, his wife, and other dignitaries. Luminaries lighted their way between the hotel and the Hall of Philosophy. (Courtesy of the Samuel M. Hazlett family.)

124

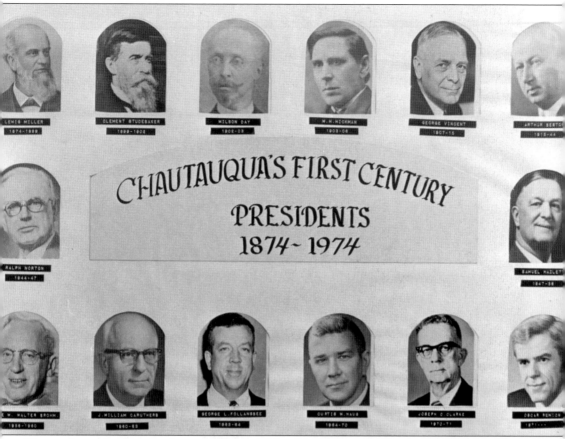

CHAUTAUQUA'S FIRST CENTURY
PRESIDENTS
1874~1974

The wisdom of cofounders Lewis Miller and John Heyl Vincent was perpetuated during the 100-year span by the adroit stewardship of each successive administration up to and including that of Oscar Remick. Each of its presidents gave to Chautauqua evidence of his loyalty and faith in its mission and in its future. Each assumed ownership and ably passed on the blessings of the past to the future caretakers. Like his predecessors, Remick helped create a climate for change, an opportunity for Chautauqua to broaden its vision and renew its vitality. With Nelson Rockefeller and members of the New York State Council for the Arts in the audience at the Albright-Knox Art Gallery in Buffalo, Remick proudly received an award for Chautauqua's "sustained activity as a performing and visual arts center of national importance."

125

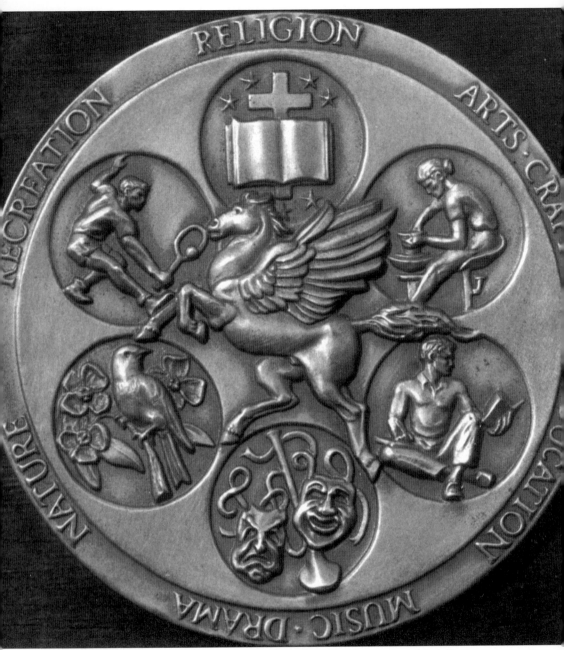

A lasting tribute to the celebration was the exquisite Chautauqua Medallion, a memento greatly treasured by exemplary recipients. America sculptor H. Richard Duhme Jr. of St. Louis was a member of the faculty of the Chautauqua School of Art for 20 years. He was highly regarded for his other commissioned awards and medals, which were exhibited in New York City and at the Smithsonian Institution. He was the obvious choice to design the double-sided commemorative piece, which measures less than three inches in diameter. Minted in both bronze and silver, it is the most coveted Chautauqua award and has been bestowed on only a few notable persons since its creation in 1974. (Courtesy of Jane Currie.)

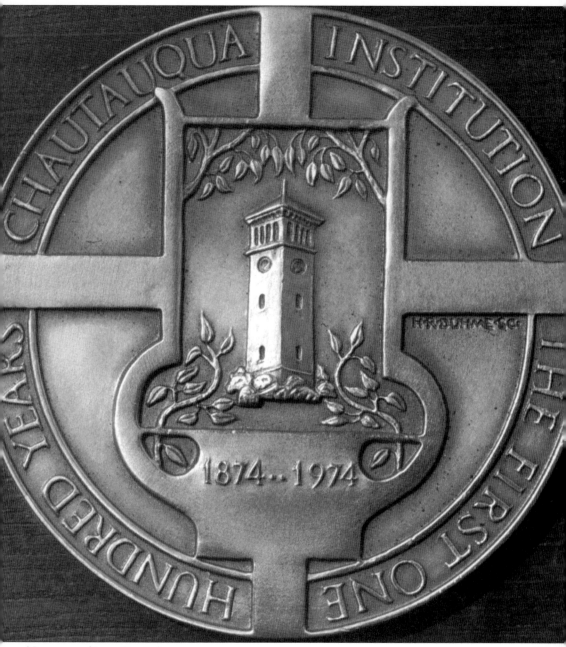

(Courtesy of Jane Currie.)

BIBLIOGRAPHY

Bray, Frank Chapin. *A Reading Journey Through Chautauqua*. Chicago: The Lakeside Press, R.R. Donnelley and Sons Company, 1905.

The Centennial History of Chautauqua County: A Detailed and Entertaining Story of One Hundred Years of Development, Vol. II. Jamestown, N.Y.: The Chautauqua Historical Company, 1904.

Chautauqua Lake Steamboats, Jamestown, N.Y.: The Fenton Historical Society, 1971.

The *Chautauquan Magazine*, June 1912, "Bishop Vincent Anniversary Number."

Cram, Mary Frances Bestor, *Chautauqua Salute: A Memoir of the Bestor Years*. Chautauqua Institution, 1990.

Downs, John P., and Fenwick T. Hadley, eds. *History of Chautauqua County, New York, and Its People*, Vol. I. Boston, New York, Chicago: American Historical Society Inc., 1921.

Fancher, Pauline. *Chautauqua: Its Architecture and Its People*. Miami: Banyan Books Inc., 1978.

Fuscus, David A., ed. *Ship Ahoy: Tales of Lake Chautauqua's Great White Fleet*. Jamestown, N.Y.: Pennybridge Corp., Publishing Division, 1983.

Gould, Joseph E. *The Chautauqua Movement: An Episode in the Continuing American Revolution*. Fredonia, N.Y.: State University of New York College of Education, 1961.

Irwin, Alfreda L. *Three Taps of the Gavel: Pledge to the Future, the Chautauqua Story*. Westfield, N.Y.: The Westfield Republican, 1987.

Morrison, Theodore. *Chautauqua: A Center for Education, Religion and the Arts in America*. Chicago and London: University of Chicago Press, 1974.

Richmond, Rebecca. *Chautauqua: An American Place*. New York: Duell, Sloane and Pearce, 1943.

The *RoundTable* magazine. 9:9, Chautauqua, N.Y.: Chautauqua Press, May 1918.

The *RoundTable* magazine. 7:1, Chautauqua, N.Y.: Chautauqua Press, September 1920.

Simpson, Jeffrey. *Chautauqua: An American Utopia*. New York: Harry N. Abrams Inc., 1999.

Talbot, Mary L. "A School at Home: The Contribution of the CLSC to Women's Educational Opportunities in the Gilded Age, 1874–1900." Dissertation, Smith Memorial Library, Chautauqua, N.Y., 1997.

Tarbell, Ida. *All in the Day's Work: The Autobiography of the Foremost Muckraker of the Time*. New York: G.K. Hall and Company, 1985 (reprint from 1939).

Vincent, John Heyl. *The Chautauqua Movement*. Boston: Chautauqua Press, 1886.

Vincent, Leon H. *John Heyl Vincent: A Biographical Sketch*, New York: The MacMillan Company, 1925.

Warren, R.M. *Chautauqua Sketches: Fair Point and the Sunday School Assembly*. Buffalo: H.H. Otis, 1878.